Digital Wildlife Photography

Digital Wildlife Photography

Chris Weston

photographers'
pip
institute press

First published 2005 by
Photographers' Institute Press
an imprint of The Guild of Master Craftsman Publications Ltd,
166 High Street, Lewes,
East Sussex BN7 1XU

Reprinted as paperback, 2008

ISBN 1 86108 480 3 (hardback)
ISBN 978 1 86108 563 4 (paperback)

A catalogue record of this book is available from the
British Library.

Production Manager: Jim Bulley
Managing Editor: Gerrie Purcell
Photography Books Editor: James Beattie
Project Editor: James Evans

Book design: Fineline Studios
Cover design (paperback): James Hollywell
Typefaces: Eurostyle and Iperion

Colour origination: GMC Reprographics, Lewes, East Sussex, UK
Printed and bound: Hing Yip Printing Co.Ltd, China

778.932
W

Dedication

Over the past few years, I have had the privilege of sharing my life with some of the world's most alluring and charismatic creatures. I have been mistaken for a tree by a grizzly bear and for a perch by a vulture. I have been sat on by a cougar cub and outwitted by a fox. I have had my beanbag eaten by an elephant and my lunch pilfered by racoons. And, perhaps most amazing of all, I have been accepted into a wolf pack and howled at the moon. Never once during these moments in the field have I feared for my life or felt unduly threatened in any way. No animal has ever attempted to deprive me of my home and shelter or considered me as sport. And despite their strength and dominance over the world in which they live, I have yet to encounter an animal that has been corrupted by its power. Of all these things, I wish I could say the same of mankind. And so, I dedicate this book to all the creatures that I have met along the way and thank them for the pictures they have given me, and the memories I now cherish.

Acknowledgements

As ever, I am indebted to the many people that have helped in the creation of this book. In the 'front office' my thanks to Stu Porter and Riaan de Villiers (South Africa), Chris Morgan and Jim Brandenburg (USA), Jeremy, Simon and the team at the HWP in Scotland, and Steve Brown (Kenya). In the 'back office' my gratitude to Justyna, Anne and John; Fraser Lynnes; Gerrie Purcell, James Evans and the whole team at Photographers' Institute Press; and, as always, to Claire and Josh. Thanks also to Kevin Keatley of Wildlife Watching Supplies, Jane Nicholson of Intro 2020 and Peter Sturt of Lee Filters.

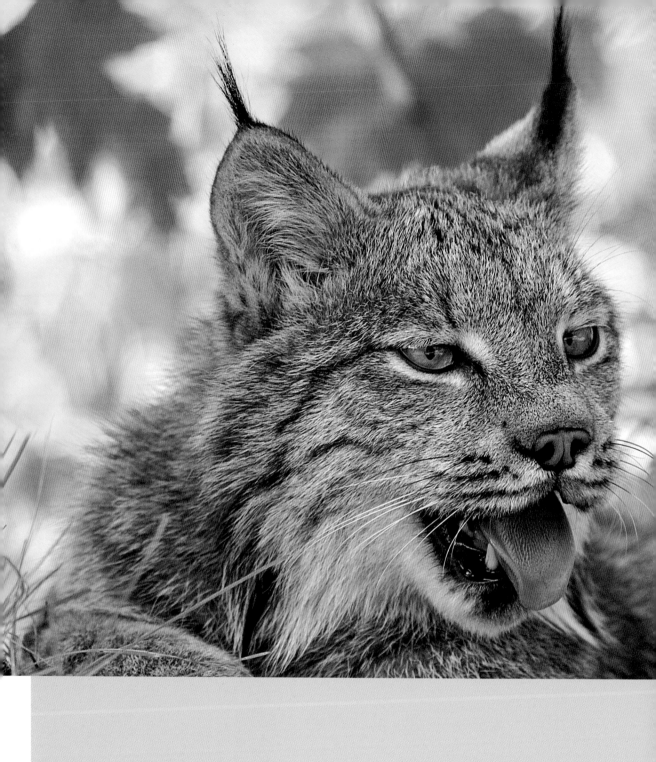

Contents

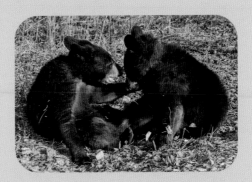

Introduction

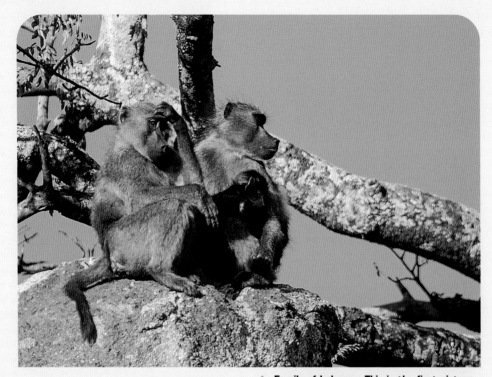

Family of baboons: This is the first picture I took with a digital camera. While it won't win any awards, the level of detail and overall quality of reproduction, particularly given the conditions in which it was taken, convinced me that digital was the way to go. *Nikon D100, 800mm lens, 1/250sec at f/5.6, ISO 200*

I am a wildlife photographer, and on 7 April 2003 I bought a digital camera. It was the relatively new (at the time) Nikon D100 and, to be completely frank, I bought it on a whim. You see, until then I was a digi-sceptic – one of the many who, at the time, thought that a digitally originated image would never match the quality of film. But, I bought the camera anyway and packed it in a dark, rarely foraged corner of my Crumpler photo-backpack for an upcoming assignment to southern Africa.

7 April 2003 – I remember the date exactly because it proved to be a milestone in my photographic career. On my second day in the field working on that job in Africa, I picked up my new D100... and never put it down again. One day of work out in the field – that was all it took to convert me to the phenomenon of digital photography.

It's difficult to define exactly what it is about digital photography that is so rewarding. Perhaps it is the ability to see instantly the image you've just photographed, or the greater flexibility that the digital medium affords. Maybe it's the pleasure of learning new techniques, or the ease and speed at which you can turn an original file into a finished print.

Digital cameras are the norm now, but still I get asked about digital-photography techniques, and so I decided to take my field notes and my scribbles, and the experience I have gained in the field, and turn them into a book. Unashamedly, this is a book about digital techniques for wildlife photographers. And, although you

will find hints and tips that are generic to photography as a whole, the principal information contained within the following chapters expands on the nuances of the digital medium and explores in depth the new techniques that you can employ when in the field with your camera.

From conquering exposure by using histograms to understanding and exploiting menus, from improving your success rate by mastering the LCD screen to choosing the most appropriate shooting parameters for your subject, I delve into the much-debated world of digital equipment, from the camera to the digital darkroom. And, talking of darkrooms, I also explain some simple image-enhancement techniques that help to overcome the limitations of the photographic process, and the photo-sensor in particular.

2008 and beyond

Since writing this book in 2005 much has changed in digital photography. Cameras have come on leaps and bounds, brought on perhaps by increased competition between manufacturers. For example, in 2005 the average resolution of a mid-range digital SLR was 6-megapixels. Today it's closer to double that. Auto-focus systems are improving and many of the features only to be found on high-end professional specification cameras are now included on mid-range and even entry-level cameras.

Developments too have been made in processing software, with the introduction of Photoshop CS3, an excellent upgrade on its already outstanding predecessor, CS2, as well as more sophisticated RAW conversion software solutions from the camera manufacturers and Adobe, but also from newcomers to the market, such as Apple. In other ways things have changed very little. The fundamental nature of digital photography remains the same and all of the techniques described in this book are as relevant today as they have been always. In this sense, digital photography, like film photography before it, is still simply photography.

In the coming years I think we will begin to see more far reaching changes. For example, Nikon's latest incarnation of DSLR camera, the D3, enables setting of ISO values beyond 25,000 – unheard of until now. As noise management improves,

American badger: ▶▶▶
Successful wildlife
photographs, especially
those that involve getting
close to animals, are as
dependent on your field
skills and bush craft
as they are on your
camera equipment
or technique.
Nikon D2H, 24–120mm
VR lens set at 120mm,
1/500sec at f/8, ISO 200

such speeds, will enable hand holding the camera in extreme low light commonplace. Camera dynamic range, i.e. a camera's ability to record detail in highlight and shadow, which, until now has been very limited, will improve to match that of the human eye. Beyond that, who really knows what's possible.

As well as the digital medium, this book is also about wildlife, and successful wildlife photography is as dependent on your field skills as it is on your photographic ones. Beyond the realm of gear and gizmos, I have examined the attributes that make a successful wildlife photographer and broken down the abilities you will need to hone in order to make images that excel. Throughout the following pages I discuss field craft, caring for equipment, and getting within an animal's circle of fear.

And, let us not forget that photography is also an art – a means of communicating your inner vision to a world of wildlife enthusiasts. Through careful attention to composition and clever placement of the elements of design – line, shape, pattern, colour and texture – you can, with the help of the following text and pictures, develop your skills to make pictures that stand above simple portraits and record shots.

I have been a professional wildlife photographer for over nine years now and I feel both humility and privilege for the times I have shared with the wonderful creatures of this world. I have had the chance to travel the globe and to witness sights that few will ever know. I share them with you in this book in the hope that a glimpse of the beauty of our wildlife, as seen through my camera, will encourage you to spend more time behind yours, making pictures that excite and abound with a passion for all things wild.

American Black bear: Successful wildlife photography challenges our preconceived attitudes to the world by producing images that excite us and contrast with our preconceptions.
Nikon D2H, 12–24mm lens, 1/250sec at f/8, ISO 320

Red fox: All animals have a circle of fear, an imaginary line that, if breached, will cause them to flee. Getting within this space without distressing your subject is the role of the wildlife photographer.
Nikon D2H, 80–400mm VR lens set at 270mm, 1/1000sec at f/5.6, ISO 200

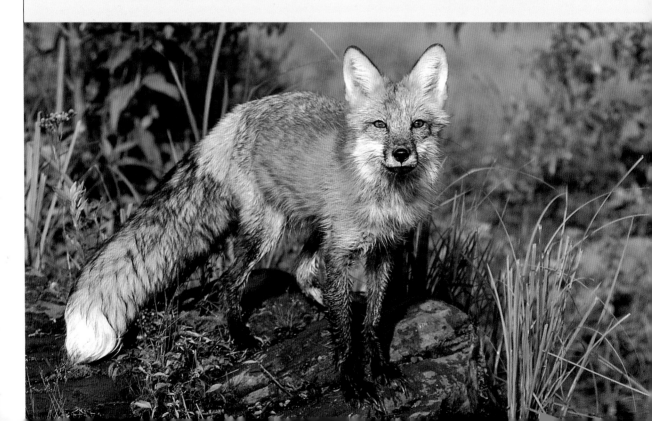

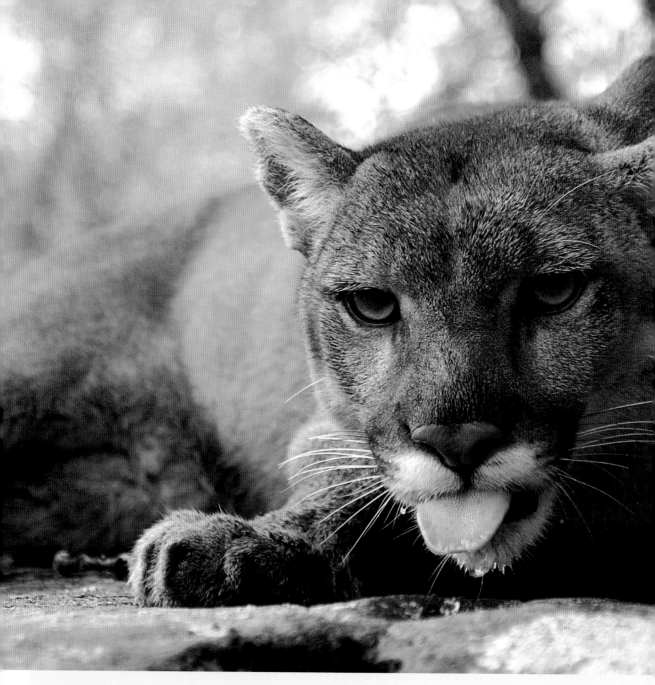

Starting Out

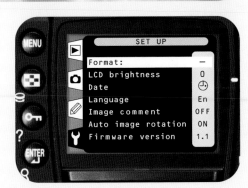

Digital cameras come in many shapes and sizes, but for the wildlife photographer at least there is really only one serious contender: the digital single-lens reflex (or D-SLR). At first glance, there is little to distinguish a D-SLR from its film counterpart, the only outward difference being the LCD on the back. If, however, you were to open it up (and I don't recommend that you do!) you would find a new world of chips and circuitry.

How digital images are made

When the shutter is opened, each photo-diode on the digital photo-sensor creates an electrical charge or signal, the value of which varies depending on the brightness of the light. Microprocessors in the camera then convert this electrical signal (which is analogue) into a digital value – effectively a number. For example, if the brightness level is low (i.e. dark) then the value is also low, pure black being zero. Alternatively, very bright light is given a high value.

The camera's processor takes the colour value produced by the colour filter array for each individual photo-diode and, interpolating it with data taken from adjacent photo-diodes, assesses true colour. The result is millions of (usually) square dots, which are known as pixels; a word derived from the term 'picture elements'. (Note: Foveon sensors assess colour in a slightly different way, using three separate sensor layers instead of a colour filter array. Currently, however, they are only found in Sigma SLRs.)

Once you have pixels, a number of things can happen to them, not least of which is their value can be altered to enhance image quality or change picture aesthetics. For example, the camera's built-in processor and software can adjust tone, hue and sharpness to exploit prevailing shooting conditions. Digital noise (see page 29) can be checked for and interpolated out, and the image can be compressed to make the file smaller and more manageable.

When an image has passed through all the levels of in-camera processing, it is transferred to the memory device, where it is stored until it is deleted.

If the file type is set to RAW mode, the camera doesn't process the image. Instead, it attaches to the file a record of the shooting parameters used, which is then accessed by the proprietary software supplied by the manufacturer or a similar software programme, such as some versions of Adobe Photoshop. This is covered in more detail on page 24.

Memory cards

Digital cameras store processed images on a memory card, commonly a CompactFlash card. These come in varying sizes from small (e.g. 128mb) to large (e.g. 4gb), and have different write-speed capabilities. A newer alternative is the Secure Digital (SD) card. This compact type of memory card allows for fast data transfer, has built-in security functions and includes a small write-protection switch similar to those used on floppy disks.

Faster write speeds improve the processing performance of your camera, although not all cameras support the relevant technology (consult your camera manual for details). The card capacity will determine the number of image files that can be stored on the card. It may seem sensible to opt for a 4gb card, as it will hold lots of images. However, I am wary of having so many pictures stored in a single place and prefer to use smaller cards (usually around 1gb) and more of them, thereby spreading any risk.

Digital capture: Light enters through the lens and is recorded by the photo-sensor. This information is converted into an electrical signal by the microprocessor, and is then temporarily stored in the buffer before being passed on to the memory card.

A tour of the digital SLR

Lens

A camera that has interchangeable lenses is ideal for wildlife photography. Choose the most expensive optics you can afford – lens quality is one of the most important factors affecting image quality.

Metering modes

To cope with different lighting conditions, many cameras have varying types of metering mode, including multi-segment, centre-weighted and spot.

Shooting mode

The shooting mode sets the speed of the frame advance. This can be single shot, multiple shots, high speed and self-timer. Frames-per-second (fps) speeds vary between cameras.

Hot shoe

Used for attaching flash units and other accessories, such as remote-control devices. The connections on the hot shoe pass information between attached devices and the camera body.

Body

The body should be strong and durable, and if you're thinking of visiting some of the more exotic locations around the world, it should be able to withstand harsh environments where dust and moisture are your camera's worst enemies.

Autoexposure (AE) settings

Sets the AE mode. Most cameras provide three types of autoexposure, as well as manual. Some consumer-grade cameras also provide various pre-programmed AE settings for simplified photography.

Autofocus (AF) settings

Switches the focus mode between AF and manual focus. While all D-SLR cameras have AF, the quality of the AF system will vary depending on the specifications of the camera and lens.

Buffer

Digital cameras store image files in an internal buffer while they are being processed. The size of this buffer will partially dictate how many pictures can be taken in a single burst. More sophisticated digital cameras have dual buffers that increase burst rates by enabling simultaneous processing.

Microprocessors

Microprocessors convert the analogue signals created by the photo-sensor into digital numbers. These processors also apply any in-camera processing that has been set by the user via the camera menus. This will alter the value of pixels to enhance the output quality of the picture.

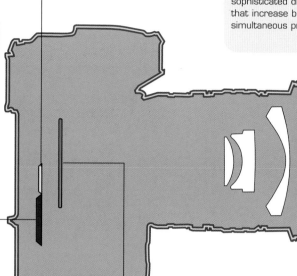

Battery

Digital cameras are very reliant on battery power. More sophisticated models use powerful Li-ion-type units, while others use standard cell batteries.

Digital photo-sensor

The photo-sensor replaces film as the means of recording light entering through the lens. Resolution is measured primarily in megapixels and, generally speaking, the more megapixels there are, the larger the final image can be displayed/printed. There are different types of sensor design (including CCD, CMOS, LBCAST), and it is important to bear in mind that sensor types are not interchangeable – once you've chosen a camera, you're stuck with what you've got.

Memory-card slot

Digital cameras store images on a memory card that slots into the camera body. These cards are available in different memory sizes (larger cards have increased storage capacity), write-speeds (which will affect burst rates), and vary in technologies used.

Function buttons

As well as accessing camera functions through the menus, many commonly used functions can be applied via buttons on the back of the camera for added speed.

LCD panel

The LCD on the rear of the camera gives you access to the menus as well as allowing you to replay instantly the image you have just taken. You can also review any images stored on the memory card.

Shooting parameters and menus

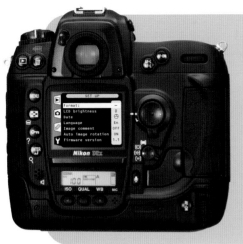

Although film SLRs are becoming increasingly sophisticated, digital SLRs offer an unsurpassed degree of control over camera operation. To get the most from this technology, it is important to make sure that your camera is set up correctly and ready for action before you start taking pictures. The first step is to get to know the shooting parameters and camera menus.

Shooting parameters

Throughout the book, I will show you how to make subtle adjustments to shooting parameters in order to maximize image quality under different shooting conditions. To get you started, however, the following table identifies some generic settings that can usually be used to achieve great results for the majority of wildlife subjects.

The shooting-parameter table shown here is in no way definitive; it represents the settings I have found will provide good direct-from-camera results on most occasions when photographing wildlife. As your level of photographic skill develops, you may want to begin experimenting with different settings. If you are considering selling your work to magazines or photo libraries, I recommend learning exactly how each of the different shooting parameters affects image quality. However, when starting out in digital wildlife photography, these settings will suit most purposes.

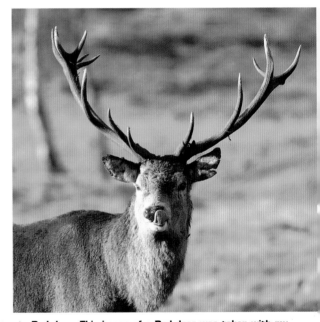

Red deer: This image of a Red deer was taken with my camera set to my default shooting parameters for wildlife photography, as shown in the table opposite.
Nikon D2H, 80–400mm VR lens set at 300mm, 1/400sec at f/5.3, ISO 200

Shooting parameters

The table below indicates some generic shooting parameters that can be used by beginners to achieve great results for the majority of wildlife subjects.

Setting	What it does	Suggested setting	Explanation	Quick alternative	More information
ISO	Determines how quickly the photo-sensor reacts to light. It is the equivalent of the ISO rating used for film	ISO 100 or ISO 200 (whichever is the lower setting on your camera)	The lower the ISO rating, the less digital noise will be visible in the final image	ISO 400 (when shooting in low light)	Page 63
White balance (WB)	Changes the sensor's response to the colour temperature of the prevailing light conditions	Pre-programmed setting CLOUDY, or around 6000K	Setting WB to CLOUDY will give your images a beautiful warm glow, much like adding an 81A or 81B warm-up filter when using film	Auto	Page 71
Colour mode	Alters the gamut of colours available for reproduction	sRGB (Nature)	Processes colours to give vivid and vibrant results, with an emphasis on green. It's the equivalent of using Fuji Velvia in film photography	Adobe RGB (particularly if you want to process your images or anticipate having your work published)	
Tone	Controls the distribution of tones and, therefore, contrast	Normal	Will produce suitable results in most lighting conditions and can be fine-tuned more easily back in the digital darkroom	Auto	Page 127
Sharpening	Adjusts the distinction between light and dark areas, affecting edge definition	Medium high	Animal fur, in particular, looks far better when edges are clearly defined	None (can be managed in-computer using unsharp mask)	Page 160
Hue	Controls the appearance of colours	0 degrees	It is easier to make subtle adjustments to colour in-computer rather than in-camera	None recommended	Page 152

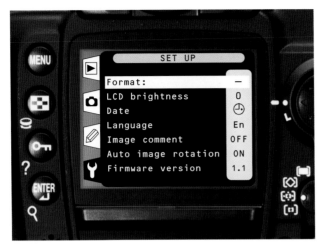

The set-up menu

The set-up menu is used to set details such as the time and date, and the language that the menus should be displayed in. It is rarely used once the camera has been set up initially.

◀◀◀ **The set-up menu on the Nikon D2H D-SLR camera. While all cameras have a similar menu, the terms they use will differ from manufacturer to manufacturer.**

Camera menus

All digital cameras have a series of menus that allow you to alter the way the camera handles, customize certain functions and features, and adjust the way the photo-sensor manages light. The level of control over camera operation and image output that menu functions provide means that never before has so much control been placed, quite literally, in the hands of the photographer.

While the number of menus and their respective names varies between camera makes and models, they all provide the same general functions. What follows is a guide to understanding some of the more common menu settings.

Another thing to note is that when you turn on your D-SLR for the first time, you will usually have to set some of these parameters – such as the date/time – before you can continue.

Option	Function
Format	Formats the memory card so it can be used with a specific camera
LCD brightness	Adjusts the brightness of the LCD screen to aid viewing
Date	Sets current date/time
Language	Selects the language menus are displayed in
Image comment	Appends a comment to an image
Auto image rotation	Automatically rotates images taken in the vertical format for easy viewing on the LCD screen
Firmware version	Denotes the current version of firmware and allows this to be updated. (Firmware updates are occasionally released by manufacturers to improve camera functions)

The shooting menu

The shooting menu contains the settings for all of the shooting parameters, such as white balance, ISO, image quality, and so on. This is the menu set that you are likely to access frequently before image-making occurs.

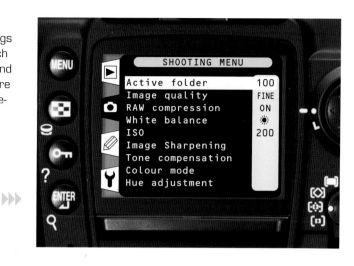

The shooting menu on the Nikon D2H D-SLR. This menu (or its equivalent) is used to set the shooting parameters before picture-taking commences.

Option	Function
Active folder	User-selectable folder where all new images are saved
Image quality	Sets the file type
Image size	Sets the image size
RAW compression	Turns on/off RAW (loss-less) compression
White balance	Sets the white balance
ISO	Sets the ISO rating
Image sharpening	Sets the level of image sharpening that is applied in-camera
Tone compensation	Sets the level of contrast that is applied in-camera
Colour mode	Sets the colour mode, which determines the range (or gamut) of colours available
Hue adjustment	Adjusts hue
Long exposure NR	Sets noise-reduction (NR) facility

Brown Bear: By setting the shooting parameters in-camera you can get as close to a print-ready image without the need for extensive computer processing later.
Nikon D100, 80–400mm VR lens set at 400mm, 1/400sec at f/5.6, ISO 200

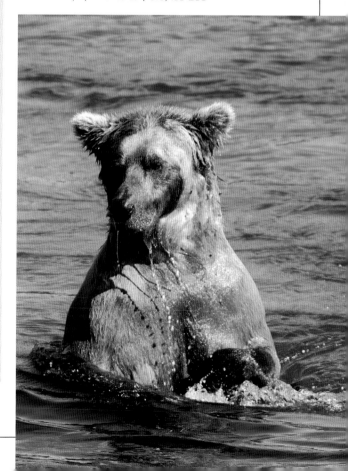

The playback menu

The playback menu controls how images are displayed after capture. In-camera editing can also be managed from this menu, as well as by function buttons on the camera back. This is the menu you will access most frequently once an image has been recorded.

Option	Function
Delete	Deletes selected image(s) from the memory card
Hide image	Hides selected images(s) from being displayed on the LCD during playback
Display mode	Selects the information to be displayed along with the image during playback, for example the histogram
Image review	Turns on/off automatic image display after capture
Protect	Turns on/off the image-protect function

The custom menu

Many D-SLR cameras allow the user to customize how some camera settings, features and functions operate, as well as the main controls, AF and AE operations, and flash settings. All custom settings are likely to be managed through the custom menu. This menu is useful for more advanced photography, once you have mastered the basics.

Option	Function
Menu reset	Resets all custom settings to default values
Autofocus	Adjusts AF settings and functions
Metering/exposure	Adjusts metering and exposure settings and functions
Timers/AE & AF lock	Sets the length of timers (e.g. self-timer) and adjusts AE and AF lock functions
Shooting/display	Adjusts shooting parameters and characteristics of LCD panel
Bracketing/flash	Adjusts bracketing and flash settings and functions
Controls	Adjusts how camera controls operate

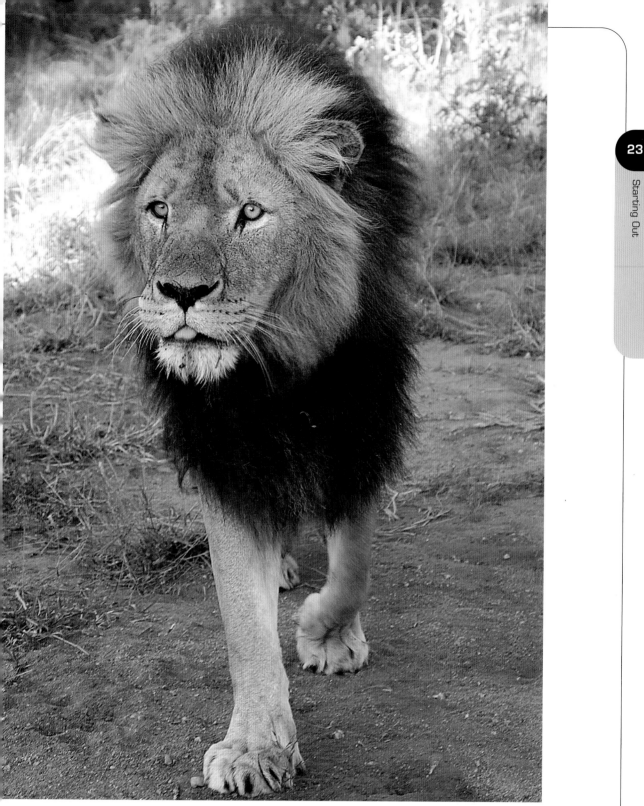

Lion: Images suitable for direct printing can be achieved in-camera if you take the time to adjust the shooting parameters in the field. Obviously, a sound knowledge of how each setting affects the final image quality is essential.
Nikon D2H, 24–120mm VR lens set at 55mm, 1/80sec at f/8, ISO 400

File types

Much has been made about whether to shoot digital images as RAW or JPEG files. Check out some of the photographic forums on the internet and you will discover an on-going, sometimes-heated debate on the subject. Ultimately, the decision comes down to what you intend to do with the pictures you take.

If you plan on doing little or no post-camera processing and want to get printable pictures straight from the camera, and if you have no plans to sell your work commercially, I would recommend setting the file type to FINE JPEG. If, however, you want absolute image quality and are prepared to put in some time in front of the computer applying the finishing touches, or if you are thinking of wildlife photography as a means to earning an income, select RAW.

For an explanation of my reasons, the following sections outline the main advantages of the two main file types.

Advantages of RAW mode

❏ When you photograph in RAW mode, shooting parameters such as white balance, sharpening and tone can be adjusted in-computer without any degradation of image quality. Think of it as having the ability to retrace your steps and re-shoot the scene at different settings as often as you like. Some argue that this is cheating, but in reality it has been happening for decades – remember Polaroid?

❏ Colour conversion and interpolation (see page 160) are managed in-computer where the algorithms used are far more complex than would be possible given the current limits of the microprocessors in today's cameras.

This results in improved image quality when compared with a JPEG file.

❏ Because RAW files take advantage of 16-bit technology, which gives over 65,000 extra brightness levels to work with, post-camera processing can be a far more expansive application with more image-processing options than are available with JPEGs.

❏ I like to have as much flexibility as possible in photography, and I am always aware of the fact that you can create a JPEG file from a RAW file but you can't do the opposite. Similarly, you can compress a large file to make it smaller, but once the JPEG algorithms have discarded their data, that information is lost forever.

Advantages of JPEG mode

❏ JPEG files are smaller in byte size and can be processed more quickly by the camera's buffer, as well as taking up less room on both your camera's memory card and on your computer's hard drive. As a guide, using a 512mb card with my Nikon D2H, I can store around 222 high-resolution or 1300 low-resolution JPEGs compared to just 79 RAW images.

❏ Because JPEG files are smaller in size, they can more easily be transmitted over the internet or via email to family, friends and colleagues.

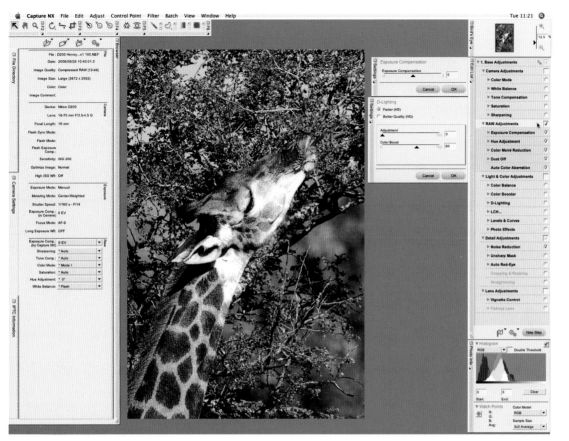

An advantage of RAW mode is enhanced post-capture processing capabilities. This image shows the tool palettes available with Nikon Capture NX processing software.

❏ Camera productivity may be improved. For example, my D2H has a burst depth of 40 consecutive FINE JPEG shots, compared to only 25 RAW.

❏ While you can argue the limitations of JPEG processing algorithms, the reality is that there is very little visible difference between a FINE JPEG and a RAW file. This is especially true for the average user, who isn't looking to earn an income from his/her images.

❏ Because JPEG files are processed in-camera, you can automatically produce finished images of high quality. This means less time in front of the computer and more time taking pictures. Moreover, most image-processing applications are capable of opening a JPEG file. The same cannot be said for RAW files, which often need the manufacturer's proprietary software before they can be opened.

Field Note

Many digital cameras now allow you to save a picture as both a JPEG file and a RAW file at the same time. Although this results in a larger overall file size, it does give you the best of both worlds: a small image that can be quickly transmitted over the internet or by email, or printed without any further processing, plus a large, high-quality image. The latter can of course be enhanced using a computer to maximize final print quality.

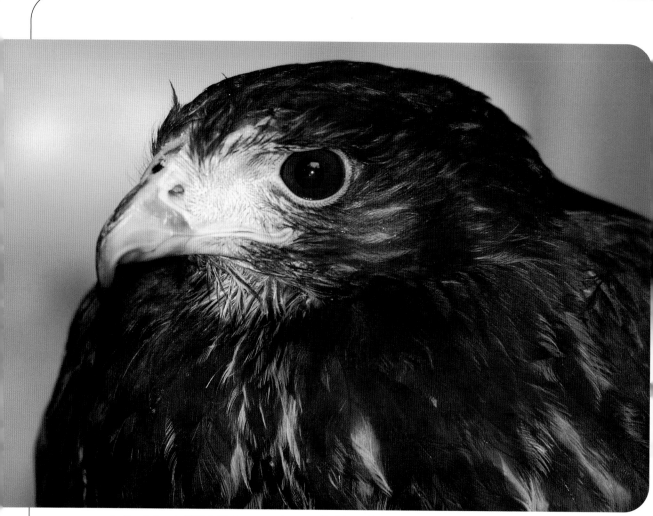

▲▲ **Harris hawk: Which file type you choose will ultimately affect image quality. This image was**
shot in RAW mode and converted to a TIFF file, thus losing no original data along the way.
Nikon D100, 80–400mm VR lens set at 400mm, 1/60sec at f/8, ISO 200

Equipment

Understanding compression

There are two types of compression used in digital photography. The first is called loss, or lossy, compression and is applied to JPEG-type files. When a file is compressed using loss-compression technology, algorithms are used to reduce the number of bytes. Once the file is compressed, some original data is discarded permanently. When the file is opened, algorithms are again used to reconstruct the image and the missing data is replaced with interpolated data, which may result in poorer image quality – e.g. an increase in the occurrence of artefacts.

The second type of compression used is called loss-less compression, and can be applied to RAW and TIFF files. Loss-less compression algorithms retain all of the original data and the reconstructed image is made up of exactly the same data as the original.

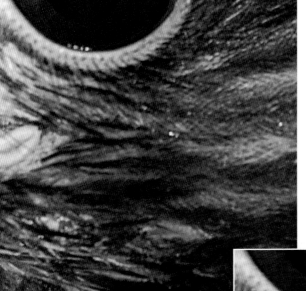

◄◄◄ **This enlarged section of the main picture shows the level of detail achieved when loss-less compression is applied.**

▼▼ **Loss (or lossy) compression, on the other hand, can degrade image quality. This can be seen when the same section of the main image is saved and printed as a low-resolution JPEG file.**

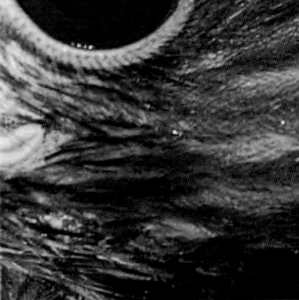

Field Note

Some cameras have a file-type setting of TIFF. TIFF files are processed in-camera and are large in file size (usually bigger than a RAW file), although they can be compressed using loss-less compression. TIFF is the standard file type used in publishing, but there is little reason to shoot TIFF in-camera. It provides no distinct advantage over a RAW file, which can be saved as a TIFF after processing and provides much greater flexibility of use.

Digital camera features

While the process of photography is similar for both the digital and film media, digital photography has some nuances that you will need to familiarize yourself with. These quirks may appear daunting at first glance, but don't be put off. Once you understand the basics, you will find that the additional flexibility of digital cameras can make successful wildlife photography a simpler and more rewarding task.

Instant playback

The most obvious and one of the most useful features of a digital camera is the LCD panel, which gives you the ability to replay immediately the picture you have just taken. This feature enables you to assess images for compositional strength, exposure accuracy and sharpness, and, if necessary and when the occasion allows, re-shoot the image to improve upon any deficiencies. You can also use instant playback to try out new techniques. Experiment with different camera settings and review the results on screen. If the experiment hasn't worked as you expected, determine the reasons why, make the necessary adjustments and re-shoot. (For more information on playback, see page 72.)

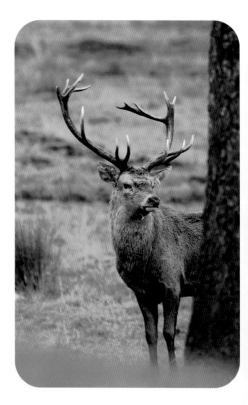

Red deer: White balance affects the colour temperature of an image. This picture has been taken with AUTO WB, which has produced a cool blue tone. By setting CLOUDY, the same picture (far right) appears much warmer.
Nikon D2H, 80–400mm VR lens set at 400mm, 1/45sec at f/5.6, ISO 320

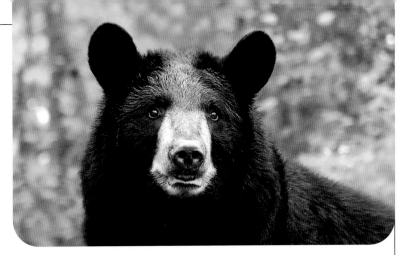

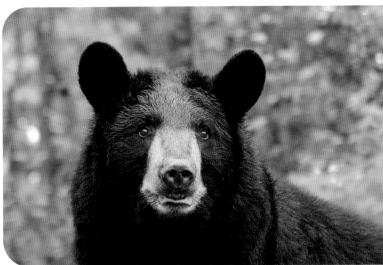

American Black bear: Digital noise can affect the shadow areas of some subjects, particularly when using slow shutter speeds or, as shown in the lower image, a fast ISO rating. Keeping the ISO below 400 will help alleviate any problems with digital noise (as shown in the top image).
Nikon D2H, 24–120mm VR lens set at 120mm, 1/40sec at f/5.6, ISO 400

White balance (WB)

Human eyesight perceives light as white, or neutral. In reality light has a colour cast – e.g. the light from a household light bulb is very orange in colour. Because our eyes automatically compensate for variances in colour temperature, we often find one type of light indistinguishable from another. However, photo-sensors need to be balanced to record the same neutral, white light that we see with our eyes. The WB setting on your camera manages this correction of colour casts, and can also be adjusted for creative purposes. (For information on using the WB setting in the field, see page 70.)

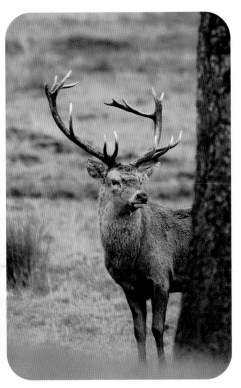

Digital noise

Digital noise, visible in an image as random, unrelated pixels is caused by several factors, two of which can be minimized via the camera. The first of these, heat, occurs when the sensor is active for an extended period, during long-time exposures. The exact duration of exposure at which noise becomes problematic will depend on the camera and other factors, but certainly any exposure that lasts for several seconds is likely to produce visible noise that is degrading of image quality.

The second factor is amplification, referred to in digital cameras as the ISO rating. At higher ISO values (increased amplification) noise becomes more prevalent. Again, the exact ISO value at which noise becomes problematic depends

upon the camera but, as a rule of thumb, with digital cameras pre-2007 around ISO 400 is the maximum recommended setting to minimise noise. Some more recent cameras are beginning to improve noise management and are less prone to noise. (Overcoming digital noise is covered on page 62.)

Equipment

Angle of view conversion chart

The table below can be used to ascertain the 35mm-equivalent angle of view for different digital formats.

	35mm film and full-frame digital	Non-full-frame digital	Nikon DX digital	Non-full-frame digital	Four Thirds digital standard
Magnification factor	1x	1.3x	1.5x	1.6x	2x
Equivalent angle of view (given in terms of focal length)	20mm	26mm	30mm	32mm	40mm
	24mm	31mm	36mm	38mm	48mm
	28mm	36mm	42mm	45mm	56mm
	35mm	46mm	53mm	56mm	70mm
	50mm	65mm	75mm	80mm	100mm
	70mm	91mm	105mm	112mm	140mm
	80mm	104mm	120mm	128mm	160mm
	105mm	137mm	158mm	168mm	210mm
	135mm	176mm	203mm	216mm	270mm
	180mm	234mm	270mm	288mm	360mm
	200mm	260mm	300mm	320mm	400mm
	210mm	273mm	315mm	336mm	420mm
	300mm	390mm	450mm	480mm	600mm
	400mm	520mm	600mm	640mm	800mm
	500mm	650mm	750mm	800mm	1000mm
	600mm	780mm	900mm	960mm	1200mm
	800mm	1040mm	1200mm	1280mm	1600mm

Note: Values have been rounded to the nearest full millimetre.

African lion cub: The photo-sensor of most D-SLRs is smaller than the standard 35mm film format. The result (shown right) is an effective increase in focal length, making subjects appear closer to the camera.

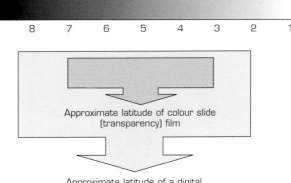

9 8 7 6 5 4 3 2 1

Approximate latitude of colour slide (transparency) film

Approximate latitude of a digital photo-sensor

Angle of view

With the exception of a few high-end, professional-specification D-SLRs, the size of the photo-sensors used in digital cameras is smaller than a standard 35mm film frame. The effect of using lenses designed for 35mm-format photography with a small-frame D-SLR is a reduction in the angle of view of the lens. By reducing the angle of view in this way, subjects within the picture space will appear nearer to the camera than they would if recorded on 35mm format. This effect is sometimes referred to incorrectly as focal-length magnification.

This diagram shows the difference in dynamic range between a transparency film (inner box) and a digital photo-sensor (outer box). Clearly, photo-sensors can cope more easily with extremes in tonality than slide film.

Autoexposure (AE) settings

The principles of exposure when using a digital camera are identical to those for film photography. However, photo-sensors have greater dynamic range than many films and can record detail in a wider range of tones. Unlike film, though, this dynamic range is uneven and a digital sensor will capture more detail in the shadow areas than the highlights. Beware of burning out (i.e. grossly overexposing) bright highlights. In digital photography, burned-out whites retain no data and so cannot be adjusted in post-camera processing.

White rhinoceros cow with calf: Overexposure is the digital photographer's greatest sin. Burned-out highlights contain zero data value and no amount of processing can retrieve the situation later.

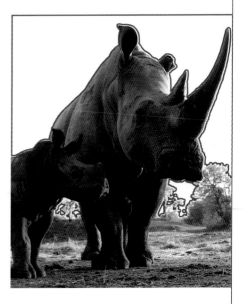

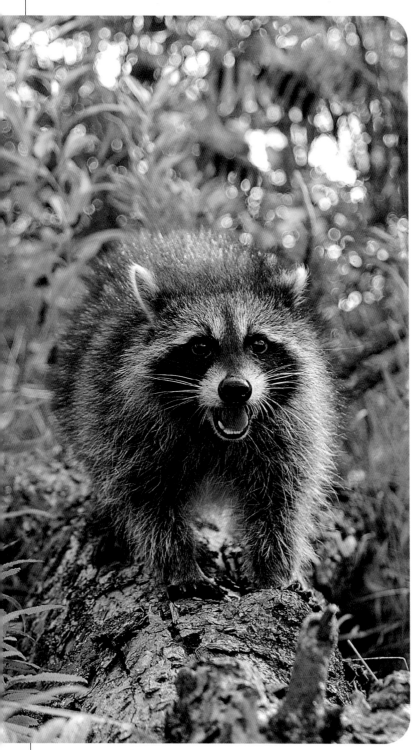

The exposure-mode dial. Preset modes are represented by the symbols.

Preset modes

Most digital cameras offer a number of pre-programmed autoexposure (AE) modes. While these can be of limited use, especially when it comes to capturing more creative images, they do offer a good starting point. Preset modes are easy to set using a rotating mode dial, and can be selected to suit the prevailing conditions. For photographing wildlife, the most common modes are: SPORT and PORTRAIT. (Note: using preset modes may affect shooting parameters other than exposure, e.g. colour mode or sharpening.)

Practically all digital cameras come with some form of autoexposure (AE) facility. Some systems are more sophisticated than others, and consumer-grade cameras tend to offer a number of pre-programmed settings to suit different subjects and lighting conditions. While most modern AE systems are fairly reliable, they do have their limitations. I'll discuss how to master digital exposure later in the book (page 58), but the following tips will work well when you first start out.

Racoon: Modern AE systems are extremely accurate, particularly when the scene has a preponderance of middle tones, such as in this image of a racoon.
Nikon D2H, 25–120mm VR lens set at 50mm, 1/350sec at f/5.6, ISO 200

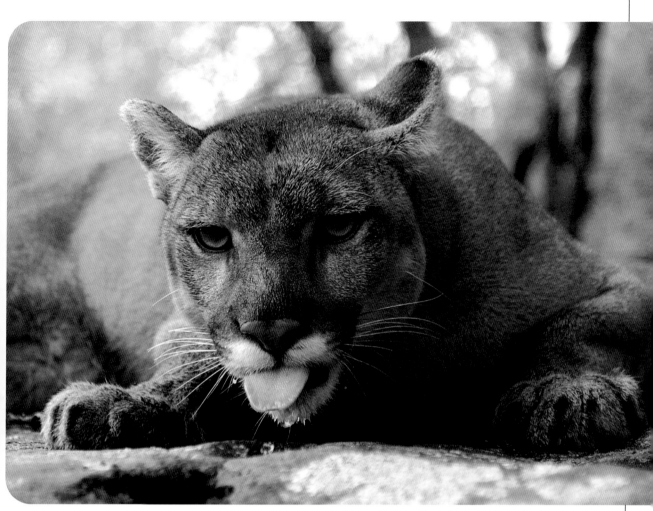

▲ **Mountain lion: When photographing animal**
▲ **portraits, the preset PORTRAIT setting**
available on some consumer-grade D-SLRs
will produce effective results.
Nikon D2H, 24–120mm VR lens set at
75mm, 1/500sec at f/5.6, ISO 320

If you want to start by using the pre-
programmed settings provided with
some digital cameras, the SPORT
setting is the one programmed most
closely for action wildlife photography.
In this setting, the camera sets both
lens aperture and shutter speed,
relative to the available light, and gives
priority to setting a fast shutter speed
to freeze the appearance of motion.

When photographing animal portraits,
however, the PORTRAIT setting is often
the most suitable option. Again, the
camera sets both exposure controls but,
in this instance, priority is given to

selecting a lens aperture that will blur
background detail in order to focus
attention on the subject.

In both modes, multi-segment metering
will provide the most reliable exposure
reading. When you feel comfortable with
taking more control over exposure
settings, I recommend using aperture-
priority AE in conjunction with multi-
segment metering. In fact, this is the
setting I use most frequently when
photographing wildlife.

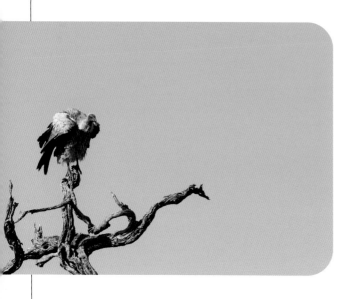

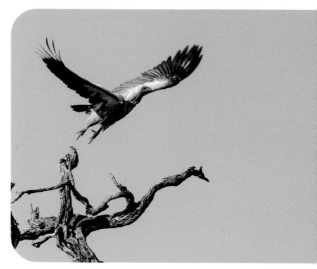

Burst depth

A standard 35mm film camera has a burst depth of 24 or 36 frames – i.e. the length of a roll of film. In digital photography, the burst depth is limited by the size of the internal memory buffer and, to a lesser extent, by the type of processor installed and the memory card used. Whether you shoot in JPEG or RAW mode will also influence the number of pictures that can be taken in a single burst, because this will influence the size of the image file.

Burst depth can be critical in wildlife photography, particularly where the requirement is for a large number of images to be taken in a short space of time, such as when photographing fast-moving subjects or sequences. Fortunately, current digital cameras have largely overcome the shortcomings of some of the earlier models. (More on managing burst depth in the field can be found on page 68.)

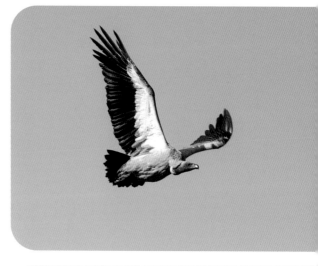

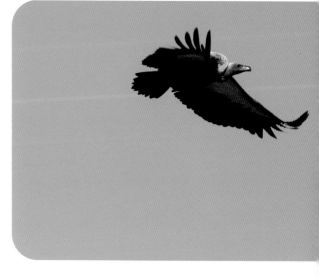

Vulture: Your camera's burst depth will determine the number of images that can be taken in sequence before the buffer fills and locks the shutter release. For fast-action wildlife sequences, a high-capacity burst depth is essential.
Nikon D2H, 80–400mm VR lens set at 400mm, 1/1000sec at f/8, ISO 200

Handling

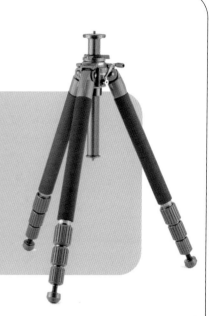

Although digital cameras provide a high level of additional functionality when compared to their film-based cousins, the skills required to handle and manage the camera are common to both formats. Some of the most important handling aspects are covered in this section.

Hand holding

Whenever possible, it's best to use your camera with some form of support, such as a tripod, monopod or beanbag. The reason for this is to reduce the likelihood of image blur caused by camera shake. However, there will be times when using a support is either impractical or impossible.

To minimize camera shake when holding the camera by hand, stand with your feet slightly apart and with your arms tucked into your sides. If there is a solid support nearby, such as a tree, wall or fence post, use this to lean against. Better still, kneel down or lay on the ground.

The camera should always be supported with both hands, the right hand holding the grip and the left supporting the lens barrel. Avoid paparazzi-style photography and the temptation to hold the camera with just one hand. When the time comes to take the picture, take a deep breath and press the shutter as you slowly breathe out. This is when your body is at its most relaxed.

When photographing action scenes, try to keep your trigger-finger on the shutter release permanently so as to avoid missing the critical shot. The layout of function buttons on some cameras can make this hard to achieve. Therefore, as best you can, make certain that all the camera settings are set for the prevailing conditions beforehand.

This is an example of how not to hold a camera. ▷▷▷

Instead, keep low to the ground, stay well-balanced and hold your arms close to your body. ▷▷▷

Anti-vibration technology

A fairly recent introduction to stills photography, anti-vibration technology has proved to be a real boon for wildlife photographers. Its purpose is to minimize the effects of camera shake by compensating for camera movement. The technology used varies; some types move an optical element in the lens, others adjust the position of the photo-sensor. Whichever method is used, however, the result is the same: a gain in shutter speed of between one and three stops (see page 58) when holding the camera by hand.

I use this technology extensively because it suits the style of my wildlife photography, and there is no doubt in my mind as to its practical application. However, don't mistake it as an easy way to get sharper images. Using anti-vibration technology successfully requires the application of good shooting technique and, ultimately, is no substitute for a tripod.

Canon, along with several other leading manufacturers, produce lenses that help to prevent the effects of camera shake.

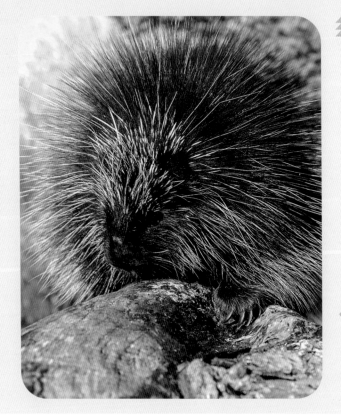

Porcupine: Anti-vibration technology will help to produce pin-sharp images when photographing hand holding the camera. The majority of my wildlife lenses now have this technology and I use it extensively.
Nikon D2H, 24–120mm VR lens set at 50mm, 1/180sec at f/8, ISO 200

Camera knowledge

There is one point I can't stress strongly enough: get to know your camera inside out so that operating it becomes second nature. For example, can you change exposure settings or focus distance in manual focus mode accurately without taking your eye from the viewfinder? And what if you had to switch from one metering mode to another, how quickly could you do it? You need to learn how to use your camera with your eyes closed.

This may seem over the top, but on the workshops I run I have witnessed many photo opportunities being lost because photographers spent too long trying to adjust their camera settings. Your camera should be an extension of your arm and you should know how to use it instinctively. For those of you that drive a car, the parallels are similar. When you first learn to drive, you are all fingers and thumbs. After a while, you know what the controls do and where they are, but you have to think about applying them correctly. Eventually, however, you no longer think about the processes involved with driving; they just come naturally to you. Well, if you want to take stunning wildlife images you should have the same level of automatic control over your camera.

Mountain lion: Photographic opportunities are often fleeting, and you rarely get a second chance. Knowing how to operate your camera instinctively can be the difference between a successful image and 'the one that got away'.
Nikon D2H, 24–120mm VR lens set at 48mm, 1/1000sec at f/11, Nikon SB-800 i-TTL flash

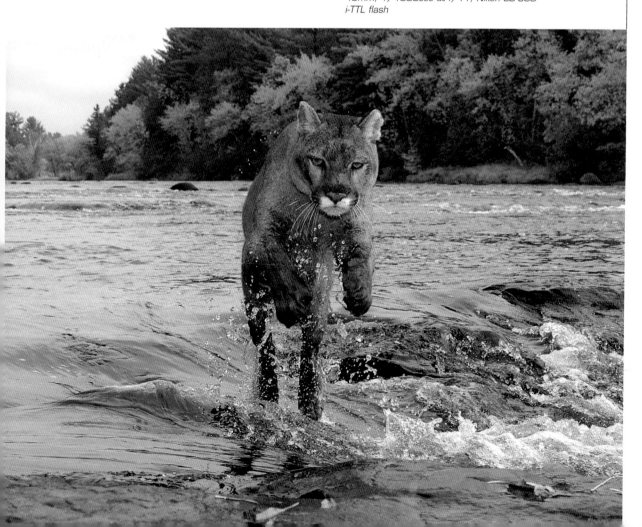

Using camera supports

If the situation allows, a camera support will help to ensure that your pictures are pin-sharp. A number of different types of camera support are available, from large, heavy tripods to smaller lightweight versions. There are also monopods, beanbags and various 'special' devices all designed to keep the camera as steady as possible.

Tripods

Tripods are the most solid form of support. They come in various sizes and you should check whether the model you use is able to support your heaviest camera/lens combination. For example, try attaching a 600mm f/4 lens and D-SLR to a flimsy tripod. At best you will get away with camera shake; at worst, you will be retrieving what remains of your gear from the ground and making a call to your insurance company.

When using a tripod in the field, keep the centre of gravity low for added stability. That means extending the legs only as high as absolutely necessary and avoiding raising the centre column at all.

There are many ways of supporting a camera in the field, from hand holding to tripods and monopods. The most suitable support will depend on the circumstances.

Equipment

Tripod heads

There are two main types of tripod head: 'ball and socket' and 'pan and tilt'. A ball-and-socket head allows you to rotate the camera around a sphere and lock it in place where you choose. Pan-and-tilt heads normally have three axes of movement that can be locked in place individually. This enables a greater degree of accuracy when framing the subject, but can be slower to operate than a ball and socket. Useful variations include gimbal heads and quick-release systems. The former are designed to give greater support and stability to heavy telephoto lenses with built-in tripod mounts. The latter incorporates a plate that can be screwed into the camera body and that snaps onto/off the tripod head. As the name suggests, this allows the camera to be detached from the tripod quickly and easily.

A good tripod should offer solid support for your heaviest camera and lens. This carbon-fibre tripod combines sturdy support and lightweight portability. A ball-and-socket tripod head is the most versatile option, but heavy super-telephoto lenses can cause problems.

Technique Tip

Increasing tripod stability

To make your camera as stable as possible when using a tripod, weigh down long lenses by placing a light beanbag on top of the lens barrel. This will help to dampen down vibrations that can cause camera shake. In very windy conditions, or when the tripod is extended to its full height, consider using an attachable weight bag to make the tripod heavier. Alternatively, if your tripod has a hook attached to the base of the centre column, hang your camera bag from it.

If you are using very long lenses, they often come with a tripod collar. In this case, attach the lens rather than the camera body to the tripod. Consider using another support for the camera body, such as a fourth arm (available with some tripod makes), or, if you want to go to extremes, a second tripod.

Finally, always use a remote shutter release when taking pictures with the camera attached to a tripod. This will avoid any chance of camera shake caused by the action of your finger pressing down on the shutter-release button.

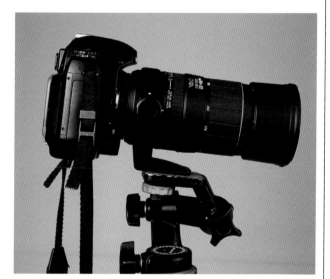

Long telephoto lenses can be extremely heavy and often come with their own tripod collar. This can be used instead of the camera's own tripod mount to improve stability.

Field Note

Avoid beanbags filled with polystyrene balls as they flatten out over time and lose their effectiveness. Natural fillers, such as maize or rice, are a better option, but beware – I once lost a maize-filled beanbag to an elephant in the middle of Africa.

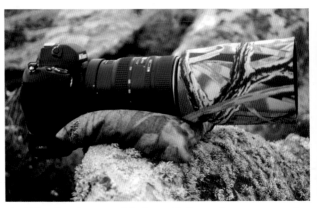

A beanbag is a surprisingly stable form of camera support, if used properly. I take more wildlife images using a beanbag to support my camera than I do using a tripod.

Beanbags

Beanbags are my favourite form of camera support when photographing wildlife. They are versatile, can be used almost anywhere, and provide excellent camera support, even when using very long lenses in combination with heavier, professional cameras.

In the field, a single beanbag is usually sufficient, although you may want to carry a spare that can be put to good use as an additional weight when necessary. If photographing from a car or other vehicle (see page 95), a double beanbag is a better option, as it can be rested over the sill of the window. Make sure that this is securely attached to something inside the vehicle to stop it from falling out – retrieving it can cause you to disturb your subject and you may lose any further photo opportunities that day.

Equipment

Monopods

A monopod is an excellent compromise between a tripod and holding the camera by hand. They are lighter to carry than a tripod and can be used practically anywhere, including most places a tripod can't. With practice, you can gain an extra two stops in shutter speed (see page 58) compared with holding the camera by hand. Beyond this, camera shake becomes noticeable again.

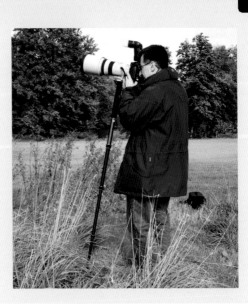

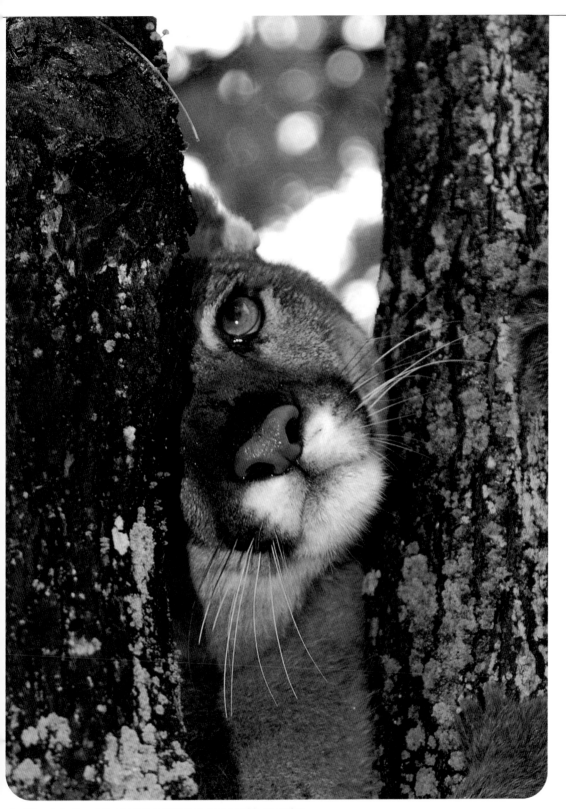

Mountain lion: I rarely use a monopod, but on this occasion found one practical for the environment I was working in.
Nikon D2H, 24–120mm VR lens set at 120mm, 1/640sec at f/5.6, ISO 800, Nikon SB800 i-TTL flash

Grey wolf (Canis lupus)

Locations:

North America, Greenland, Europe, and Asia.

Habitat:

Temperate and coniferous forest, including woodland; mountains; tundra.

For centuries, man's relationship with the wolf has been fraught. For some, it is a creature to be revered; for others, denigrated. Hunted to the point of extinction – and to extinction in some regions – wild wolf populations can now be found only in small clusters around the world. Social animals that live within a well-organized and sophisticated pack structure, they make an enigmatic subject for wildlife photographers.

Wolves make evocative subjects. The key is to photograph them with a creativity that excites our emotions.
Nikon D2H, 80–400mm VR lens set at 310mm, 1/30sec at f/16, ISO 200

Winter is an excellent time to photograph Grey wolves, when the flurry of snow adds to the atmosphere of the image.
Nikon D2H, 80–400mm VR lens set at 260mm, 1/50sec at f/5.3, ISO 400

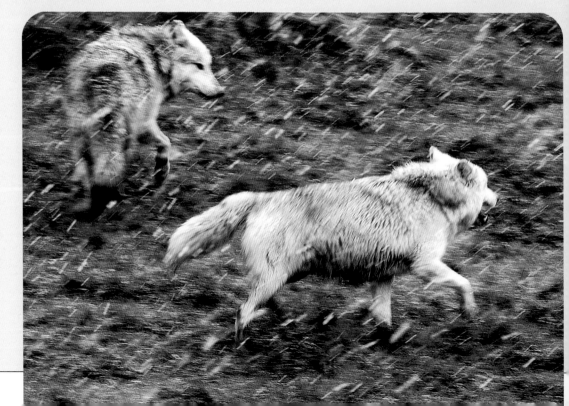

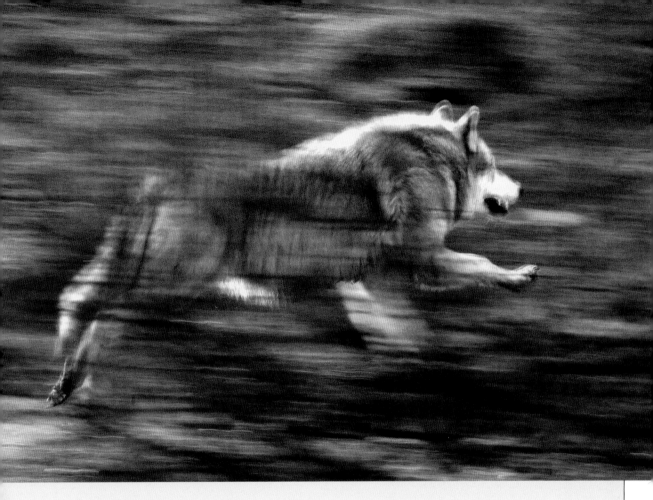

Best location for photography: wolves are naturally shy animals and will generally avoid contact with humans, which makes finding them in the wild all the more difficult. The best location for photography of wild wolves is in Yellowstone National Park in the USA, where protection from predation and more frequent encounters with man has made them less wary of our presence.

Best time of year for photography: although wolves are active throughout the year, winter is perhaps the most aesthetically pleasing time to photograph them. Not only is the landscape stunning, the wolves are also looking their best, with beautiful, thick fur coats. Due to the scarcity of food at this time of year, wolves are more active and easier to spot. If you want to photograph young wolves, pups emerge from the den around May and June.

Shots to look out for: behavioural displays, such as howling and pack interaction; feeding on a carcass; female with pups after the breeding season; wolves in their environment, particularly during the winter season.

Specialist equipment needed: a long, fast telephoto lens (400mm plus), with a teleconverter, will reduce the optical distance between you and your subject.

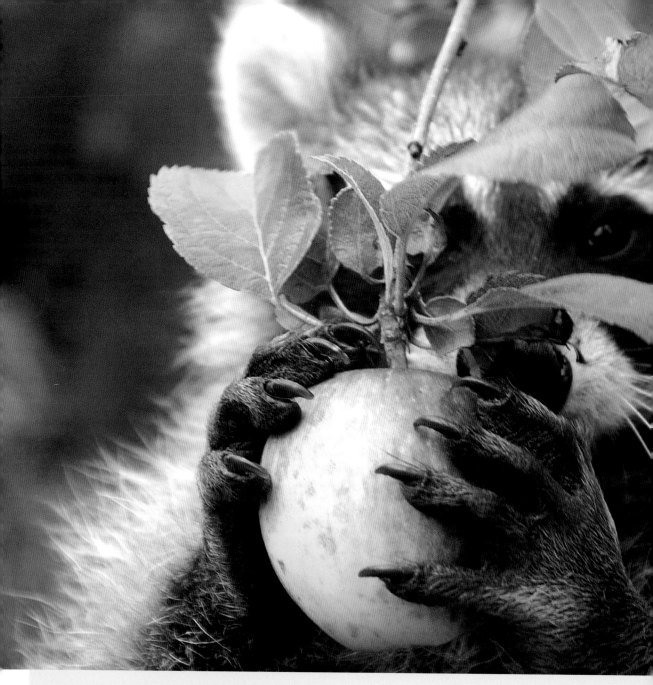

In the Field

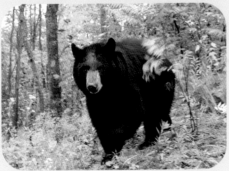

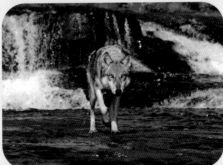

Planning the trip

Careful planning and preparation can save much wasted time in the field and usually results in more great pictures more often. Whenever I go on a field trip, I have to come back with several hundred images to show for my efforts; otherwise I'm either out of pocket or out of clients. I'll take twice the time to plan an assignment as I'll spend actually out in the field. Success doesn't come by chance.

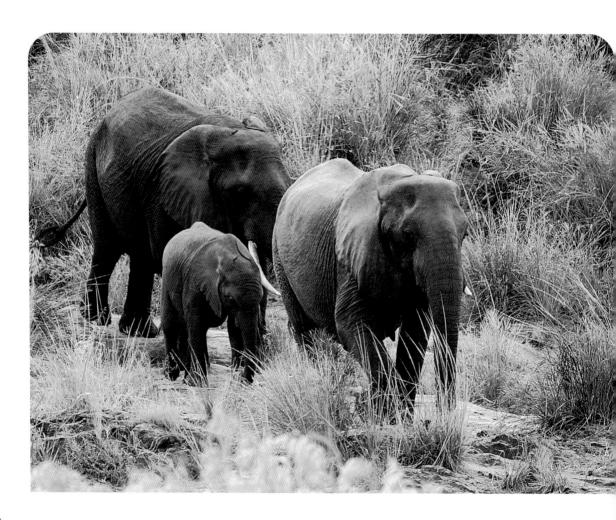

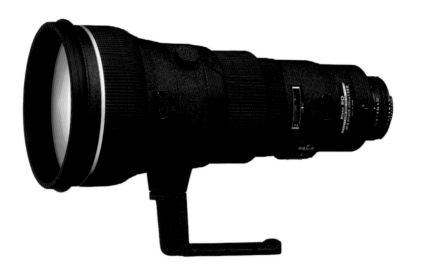

While not always essential, long telephoto lenses will help to create frame-filling images of distant subjects.

Begin by studying the area you will be visiting. In particular, consider which environments and habitats you are most likely to locate wildlife subjects in. Books, magazine articles and newspapers are a useful source of information, as are the local tourist offices and wildlife organizations, both private and governmental. Of course, in our digital world, the internet can be a fount of knowledge – I have yet to find a subject that doesn't have at least one website devoted to it!

If you are going to be photographing a particular species, study its behavioural patterns. The better you know your subject, the more likely it is that you will be able to anticipate images and the more successful your photography will be. Again, books can be an invaluable source of information.

Once you know where you are going and what you will be photographing, make sure you have all the gear you will need.

◀◀◀ **African elephant herd: Elephants never go anywhere without a plan and neither does a successful wildlife photographer. Having a goal and some idea of how to achieve it is the key to productive wildlife photography.**
Nikon D100, 800mm lens, 1/125sec at f/5.6, ISO 200

For example, if you are using remote-control photography techniques, do you have a remote-control cord and will it extend far enough for your needs? Check equipment to make sure it's all in working order. Replace batteries with new ones and fully charge rechargeable batteries.

Telephoto lenses

At this stage you may want to start building up your kit bag. First on your shopping list is likely to be a longer telephoto lens, such as a 300mm or 400mm lens. These large lenses don't come cheap, but they do give a powerful magnification factor. This will reduce the optical distance between you and your subject, making the subject appear larger in the frame.

Many years ago, I remember mirror lenses being the latest craze. Their main advantage is their small size compared to normal lenses of the equivalent focal length. However, the quality of the image they produce does not match that of modern zoom or prime lenses, and I would avoid using them.

Teleconverters

If the price of a super-telephoto lens (see page 116) is beyond your budget, a less expensive alternative is to use a teleconverter with one of your shorter telephoto lenses. Adding a 2x teleconverter to a 200mm lens will give you a focal length of 400mm. Used with a 300mm lens, the same teleconverter would increase focal length to 600mm.

When you add a teleconverter to your lens, although you effectively increase the focal length, the minimum focusing distance remains unchanged. Depth of field (see page 54) will be the same as for a lens with the equivalent focal length and aperture. For example, depth of field is the same for a 600mm lens at f/11 as it is for a 300mm lens with a 2x teleconverter at f/5.6 (the teleconverter reduces the aperture by two stops, giving f/11 from f/5.6).

There are, however, downsides to these devices. The first is a slight reduction in image quality, although used skilfully the extent of any degradation is barely visible. The second is a reduction in maximum aperture (caused by extending the distance between the lens and the focal plane). This loss is two stops with a 2x teleconverter, which gives a lens with a maximum aperture of f/4 an effective maximum aperture of f/8.

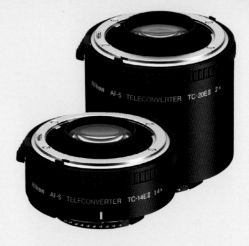

Teleconverters are an inexpensive way to extend the focal length of your long lenses. They come in different magnifications, the two shown here being 1.4x and 2x.

When deciding whether or not to use a teleconvertor, it is also worth taking into account the effect of your D-SLR's sensor size. A Four Thirds sensor, for example, already gives an effective magnification factor of 2x (see pages 30–1).

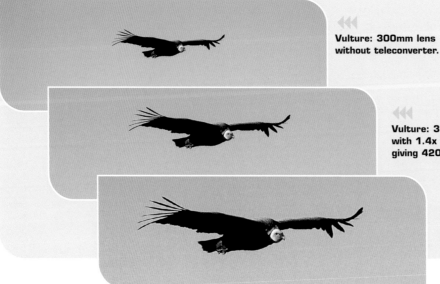

◀◀◀ **Vulture: 300mm lens without teleconverter.**

◀◀◀ **Vulture: 300mm lens with 1.4x teleconverter, giving 420mm.**

◀◀◀ **Vulture: 300mm lens with 2x teleconverter, giving 600mm.**

Packing equipment

How I pack my equipment depends on where I'm travelling and, in particular, whether I'm travelling overseas. When working locally or within my home country, I use a large photo backpack made by Crumpler. In here I place all my essential equipment. Sundry items I carry in a separate case and transfer them to the Crumpler bag as and when I need them.

For overseas travel, I again place essential equipment in the Crumpler photo bag but then place this inside a large, heavy-duty hard case made by Storm. This case, which is capable of withstanding the most enthusiastic of baggage handlers, then goes in the hold of the aircraft.

I also carry an additional smaller case containing a single camera body, two zoom lenses (24–120mm and 80–400mm), plus a flash unit and memory cards, onto the plane with me. This way, if my main baggage ends up in Azerbaijan when I'm in Alaska (it wouldn't be the first time!), at least I have something to shoot with and won't lose too much time in the field.

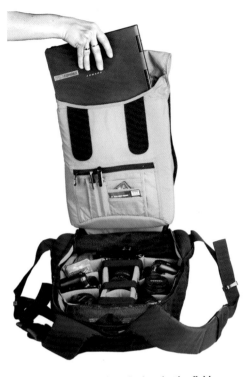

For localized work and when in the field, I carry equipment in a large photo-specific backpack made by Crumpler.

◄◄◄ **For overseas travel, I pack equipment into a special case manufactured in hard moulded plastic that, when closed, is both air- and water-tight and impervious to enthusiastic baggage handlers.**

Field Note

Remember: digital cameras, memory cards and memory devices are unaffected by the X-ray machines used in airports, so your images will be safe whether passed through as hand luggage or via the hold.

Focus and depth of field

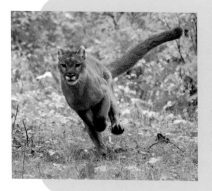

Accurate focusing is critical to wildlife photography, so it is important that this area is fully understood before you set out into the field. All current D-SLRs come with autofocus (at least, I don't know of one that doesn't) and wildlife photography provides one of the greatest challenges to any AF system.

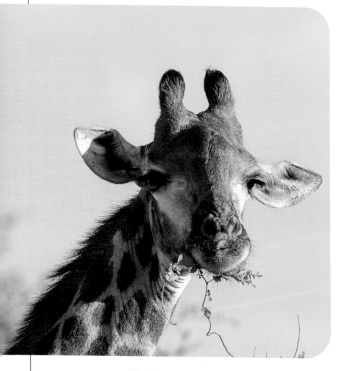

▲ **Giraffe: When photographing animal portraits, I have the AF setting on my camera set to single-servo mode. Once the shutter-release is pressed, focus is locked until you let go or the picture is taken.**
Nikon D2H, 300mm lens with 2x teleconverter, 1/250sec at f/11, ISO 200

In autofocus (AF) mode, the camera attains focus when one or more of the AF sensor targets in the viewfinder is placed over the subject and AF is activated, usually by pressing down part way the shutter-release button, or by pressing the AF ON button.

There are two main AF systems: single servo and continuous servo. In single-servo mode, once the camera has attained focus it locks the focus distance so long as AF is active. If the subject moves, focus distance remains unchanged unless you reset and reactivate AF. This system is usually suitable for animal portraits and simple record shots but, as wildlife is rarely stationary, it is less suitable for the majority of subjects.

The alternative is continuous servo. In this mode, the camera attains focus in the same way but leaves the focus distance unlocked. If the subject moves closer to or further away from the camera, it will track the movement of the subject and adjust the focus distance accordingly. The theory is that the subject will remain in focus so long as AF is active. This is generally the preferable setting when photographing animals in action.

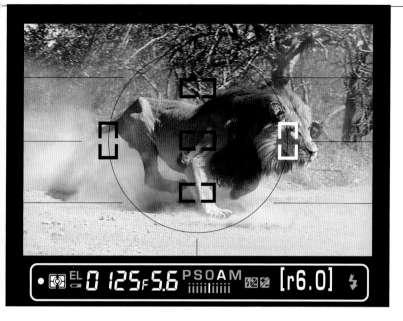

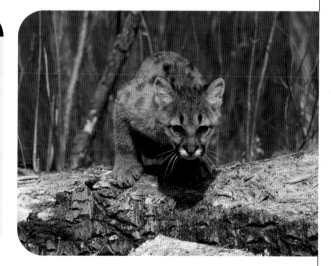

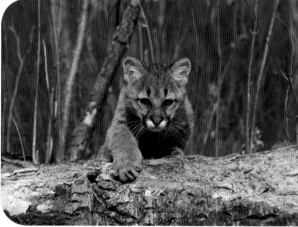

◀◀◀ **African lion: In most cases, the eye is the most important part of any animal to get absolutely sharp. Make sure that when you frame the shot the active AF target sensor covers the eye of your subject.**

▽▽ **Mountain lion: When your subject is moving, continuous-servo mode will allow the camera to track the movement of the subject within the picture frame and adjust focus distance accordingly.**
Nikon D2H, 24–120mm VR lens set at 120mm, 1/1000sec at f/7.1, ISO 200

Field Note

In single-servo AF mode, priority is usually given to focus. If the subject is out of focus, the camera deactivates the shutter. This prevents out-of-focus pictures and may be why the camera sometimes fails to fire the shutter. In continuous-servo mode, priority is most often given to shutter release and you can activate the shutter whether or not the subject is in focus.

Predictive focus

Because not all AF systems are created equal, when focusing on fast-moving subjects, such as birds in flight or big cats, you may find that the camera/lens combination you are using isn't quite up to the job. All is not lost. You can try a technique drawn from the ancient photographic gods: manual predictive focus.

Set your camera to manual-focus mode and focus on a point along the line of travel where you plan to take the picture. Then, going back to the subject, frame it in the viewfinder (making sure you have allowed enough space for the animal to move within the frame without dropping out of the picture space).

Using the panning technique described on page 136, follow the movement of the subject and activate the shutter when it reaches your predetermined point of focus. Should your D-SLR have automatic continuous frame advance, you may consider firing a series of images. In this case, start just before the animal passes into the predetermined focus point.

The key to getting this technique to work is making sure that you keep up with the movement of your subject and that you time the firing of the shutter to coincide with the point of focus. As such, it is a technique that is particularly practical when you can anticipate the subject's movements.

To avoid a blurred background (caused by the camera panning), set your camera on a tripod and simply wait for your subject. As soon as it reaches the appropriate point, fire the shutter. You will need a fast shutter speed to freeze the action.

Field Note

If you find that your AF lens is constantly active without ever finding focus, consider switching to manual-focus mode. It may be that the level of contrast is too low for the camera to determine the subject from the background, or that some foliage is obscuring the subject, making AF operation unreliable.

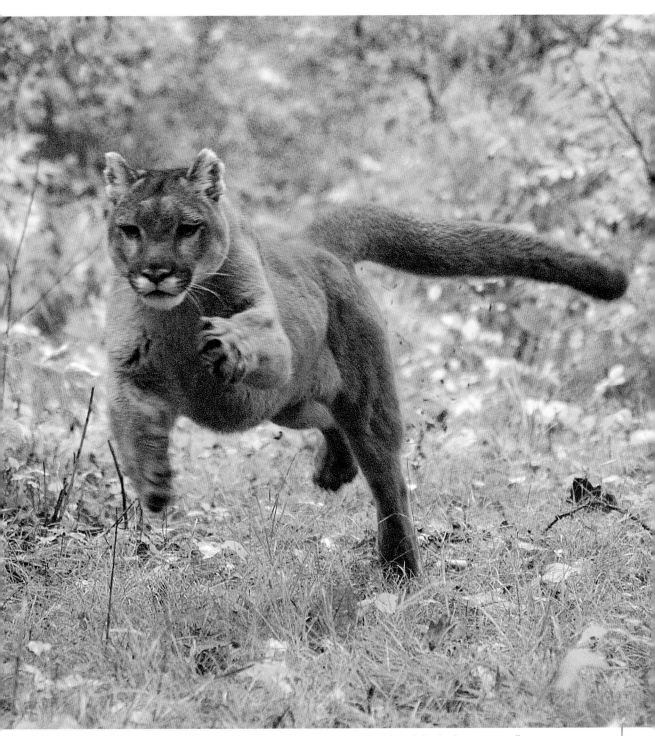

This scene is typical of the type that will confuse your AF system and frustrate any attempts you make to focus using AF. Switch to manual focus for best results.
Nikon D2H, 80–400mm VR lens set at 120mm, 1/200sec at f/16, ISO 200

Mountain lion: Animals that are speeding straight towards you are often too fast for many AF systems to keep pace. Use the manual predictive focus technique described to keep the shot from blurring beyond all recognition.
Nikon D2H, 24–120mm VR lens set at 120mm, 1/320sec at f/5.6, ISO 800

This diagram illustrates a typical viewfinder, showing five AF target sensors. An individual sensor can be selected, depending on which subject you want to focus on.

Focusing on off-centre subjects

This technique applies to attaining focus on a subject that falls outside of any of the AF target sensors in the viewfinder. Always bear in mind that the critical features are the eyes. With a static subject and the camera set to single-servo AF mode, place one of the target sensors over the eyes of the animal and lock focus by pressing down the shutter-release button half way, or pressing the AF-L (lock) button on the camera. Then, keeping AF locked, quickly recompose the image and take the picture.

When the subject is moving continually, the process becomes a little more challenging. The trick is to switch the camera to continuous-servo mode, attain focus using the AF target sensor closest to the subject's eyes and then follow the movement of the animal within the viewfinder, allowing the camera to track focus. You will need to set the AF mode so that all of the target points are active.

Field Note

If light levels allow, it can be useful to set a smaller aperture (e.g. f/11 or f/16). This will increase depth of field and subsequently make attaining exact focus on the eye a bit less critical. The longer the focal length of the lens, the smaller the aperture will need to be to acheive the same depth of field (see page 61).

Depth of field

There is only one point of focus. Everything in front of and behind that point is technically out of focus. However, because of the limitations of the human eye, an out of focus area of the scene can *appear* sharp. This area is known as the zone of acceptable sharpness, or depth of field, and is shown in the diagram, right.

Depth of field is influenced by three factors: the lens aperture, the focal length of the lens and the camera-to-subject distance.

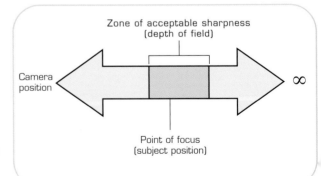

Depth of field extends from somewhere in front of the point of focus to somewhere beyond it. The true extent of depth of field is dependent not only on photographic parameters but also on visual influences, such as the quality of one's own eyesight.

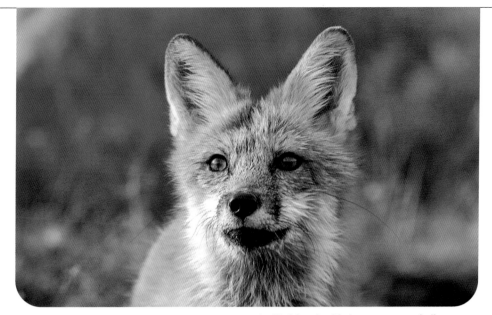

Compositionally, depth of field can be used to influence how we read a picture. Minimal depth of field, where foreground and background detail is blurred, will emphasize the subject, isolating it from the surrounding environment. A large depth of field, where peripheral detail appears sharp, will accentuate space and give a subject a sense of place.

Red fox: In this image, a very shallow depth of field, created in part by using a wide aperture, has helped blur the distracting background and placed the emphasis where I wanted it – on the fox. *Nikon D2H, 80–400mm VR lens set at 400mm, 1/250sec at f/8, ISO 200*

Racoon: Clever use of depth of field can greatly influence the impact an image makes on the viewer. The key to getting this image right was balancing levels of sharpness to place the main (apple) and secondary (eye) emphases where I wanted them without destroying the effect. *Nikon D2H, 24–120mm VR lens set at 78mm, 1/180sec at f/8, ISO 200*

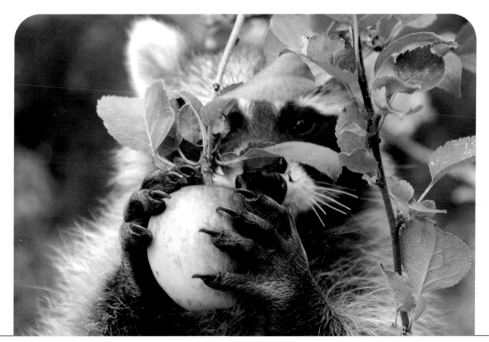

Technique Tip

Hyperfocal focusing

In essence, hyperfocal focusing is a way of maximizing depth of field. It makes use of two factors: first, the fact that depth of field extends roughly two-thirds behind the point of focus and one-third in front of it; and, second, the ability to set focus to infinity.

The benefits of hyperfocal focusing can be illustrated using a simple example. With the lens focused on infinity, depth of field will stretch from somewhere (the hyperfocal distance) in front of the camera – let's say 10m in this instance – to infinity. If you refocus the lens at the hyperfocal distance, depth of field will increase; it will now start halfway between the camera and the hyperfocal distance (i.e. 5m), and will extend to infinity.

You will notice that the technique relies on finding and then focusing on the 'hyperfocal point'. This is the point closest to the camera at which objects appear to be sharp (when focused on infinity). It can be found using three methods. If your camera has a depth-of-field preview button, it can be seen through the viewfinder – just focus on infinity and then depress the button to reveal the closest point that is still in focus. Alternatively, some lenses have a depth-of-field scale. Simply set the depth-of-field marking to the correct aperture, then focus the lens so that the infinity symbol is aligned with the outer depth-of-field marker. The final option is to use the depth-of-field chart supplied in the lens's manual.

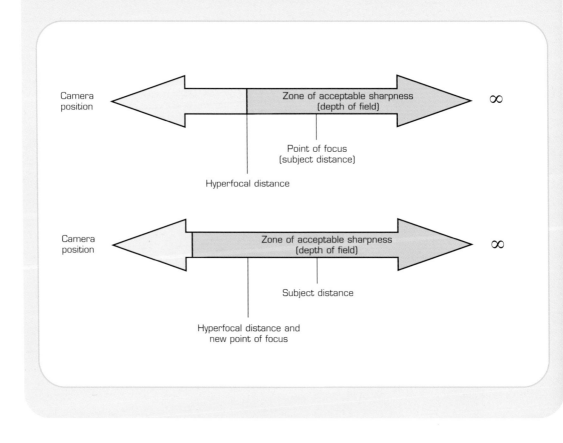

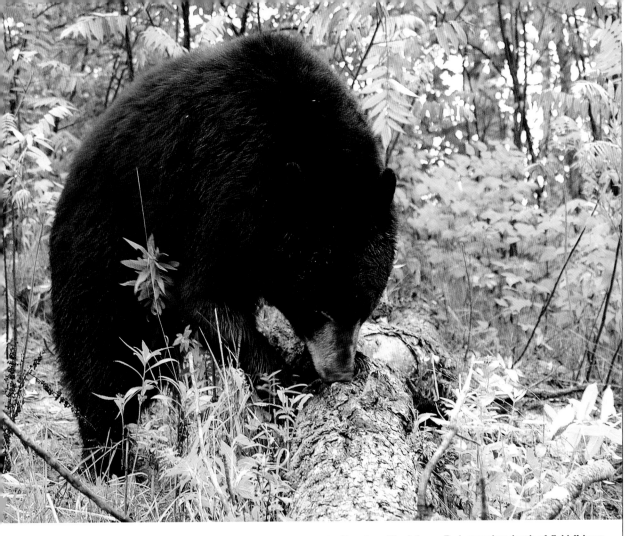

American Black bear: By increasing depth of field (I have used a short focal-length lens and a small aperture) some of the emphasis in the photograph is taken off the subject and given to the location, creating a greater sense of place. *Nikon D2H, 24–120mm VR lens set at 40mm, 1/45sec at f/5, ISO 400*

Equipment

Depth-of-field preview

Some cameras have a depth-of-field preview button that stops down the lens to its working aperture, allowing you to preview depth of field through the viewfinder in 'real time'. It takes some getting used to because at smaller apertures the viewfinder becomes darker, and seeing anything at very small apertures can be a struggle. However, it's worth persisting with because it will allow you to make a more accurate assessment of depth of field than can be gained by reviewing an image on the camera's LCD screen.

Exposure and histograms

Although you can leave a camera's pre-programmed settings to make exposure decisions for you, doing so will limit your opportunities for making creative images. Switching to either aperture or shutter-priority mode will allow you to have some creative input without taking on complete responsibility for managing accurate exposures. In so doing, you will more readily be able to create the images you want, rather than be disappointed when the camera gets it wrong.

Understanding stops

In photography, we use stops as a measurement of light, although most camera settings can also be adjusted in increments of one-third and one-half of a stop. The amount of light entering the camera is doubled by every one-stop increase in the size of the lens aperture. Reducing the aperture by one stop will halve the amount of light entering the camera. Conversely, increasing the shutter speed by one stop will halve the length of time the photo-sensor is exposed to light, while reducing shutter speed by one stop doubles the length of time the shutter is open.

When you adjust one exposure parameter (either shutter speed or lens aperture) you must make an equal and opposite change in the other to retain parity. This is known as reciprocity law. For example, if you have an exposure setting of 1/200sec at f/11 and you adjust the lens aperture to f/8, you are effectively letting in twice as much light. To compensate for this and retain an accurate exposure, you would alter the shutter speed to 1/400sec, halving

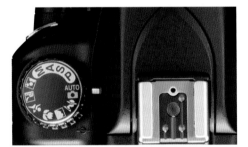

Although many cameras come with a number of pre-programmed AE settings, understanding how exposure works will help you to create images that stand apart from the mediocre.

the length of time the shutter remains open. (If you have ever used a film camera, you may have heard of reciprocity law failure, which can occur during long or very short exposures. Luckily for us, this phenomenon does not affect digital sensors. However, long exposures are more prone to digital noise, as discussed on page 62.)

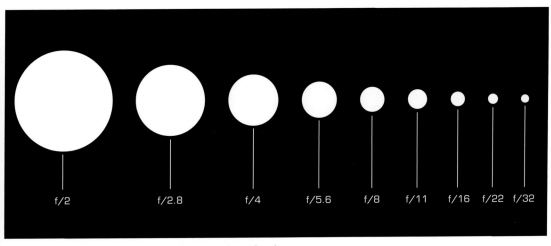

Aperture diagram: This diagram illustrates how the size of the aperture decreases as the f-stop increases. Each increase in the f-stop halves the amount of light that passes through the lens.

Exposure Value (EV) chart: This chart illustrates how exactly the same amount of light passes through to the photo-sensor at different shutter speed/lens aperture settings. For example, at EV 8 the exposure settings 1/60sec at f/2 to 4 seconds at f/32 will produce an equivalent exposure.

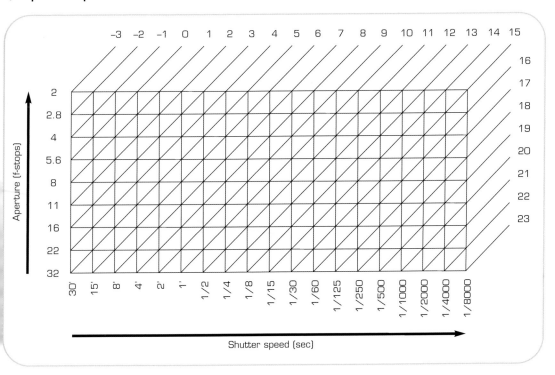

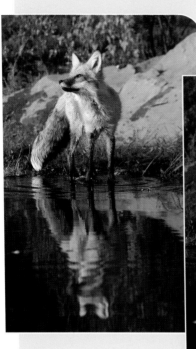

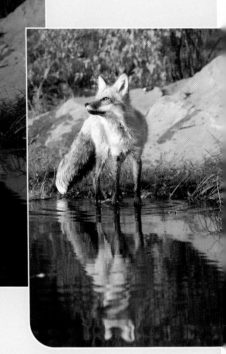

Bracketing

When you first start taking pictures, it can be a good idea to bracket your exposures. Bracketing is a technique where you take a number of pictures of the same subject but at different exposure settings – usually one at the camera's advised setting, one underexposed by about half a stop and one overexposed about half a stop (from the camera's reading). One-third and one-stop increments are also available on most digital cameras. Alternatively, the auto-bracketing function can be used to complete the process for you.

The idea is that at least one of the exposures will be accurate. To some extent, histograms (see page 64) and RAW files have made bracketing less essential. Also, bracketing may be not ideal for action sequences – the most accurate exposure may not coincide with the most pleasing shot.

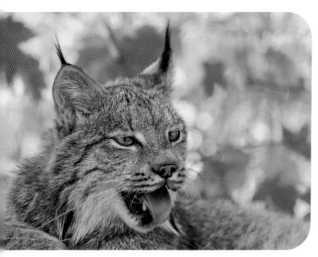

Lynx: Depth of field is, in part, determined by lens aperture. A large aperture will reduce depth of field, rendering parts of an image that are distant from the point of focus blurred and indistinguishable.
Nikon D2H, 80–400mm VR lens set at 180mm, 1/320sec at f/5.6, ISO 200

Lens aperture and depth of field

Lens aperture controls how much of the scene appears sharp – referred to as the zone of acceptable sharpness or depth of field (see page 54). This, in turn, will affect the visual relationship between your subject and the other pictorial elements in the picture space.

A small aperture, such as f/16 or f/22, maximizes depth of field and renders more of the scene sharp. When used in wildlife photography, this will help you to photograph animals in the context of their environment, creating a sense of place. A large aperture, such as f/2 or f/2.8, will create a 'shallow' depth of field in which much of the foreground and background will be blurred.

Grey wolf: A small aperture increases depth of field, making distant objects more discernable and changing the visual weight of the photograph in a way that gives less emphasis to the main subject.
Nikon D2H, 24–120mm VR lens set at 120mm, 1/1250sec at f/8, ISO 200

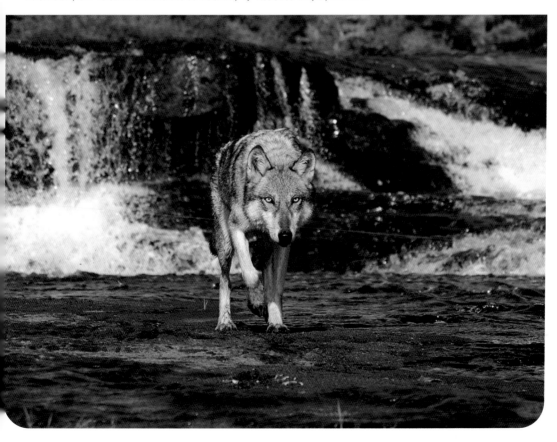

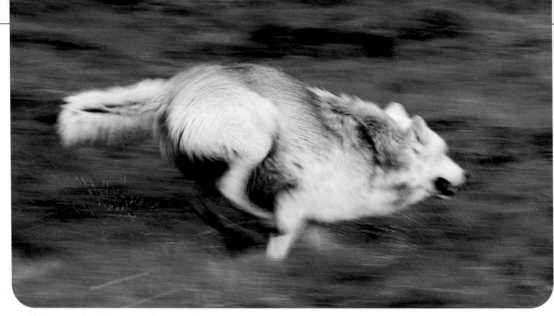

Grey wolf: Shutter speed has a major impact on the appearance of motion. In this image, I have used a slow shutter speed to create image blur and give the scene a more dynamic appearance.
Nikon D2H, 80–400mm VR lens set at 175mm, 1/45sec at f/8, ISO 200

With the camera set to aperture-priority autoexposure (AE) mode, you set the lens aperture and the camera will automatically set a shutter speed for a correct exposure. When you adjust the aperture setting you will notice that the shutter speed changes accordingly. So, when you reduce the aperture (letting in less light), shutter speed slows to increase the length of time the photo-sensor is exposed to the light. Conversely, when you increase aperture (letting in more light), shutter speed increases to reduce the duration of exposure.

I tend to stick with aperture-priority mode for wildlife photography, even when photographing action scenes. The advantage to this set-up is that the range of shutter speeds far exceeds that of lens-aperture settings. This ensures that exposure settings are nearly always within range of the camera's capabilities for any given level of light, making it less likely that you will miss a shot.

Technique Tip

Reducing 'noise'

It is unusual to use extended exposure times in wildlife photography; after all, animals rarely stay still long enough. However, if your shutter speed happens to be slower than a few seconds, you may find that digital noise affects image quality. When setting very slow shutter speeds, switch on the noise-reduction (NR) function via the menu. Beware, however, that this setting may slow down the speed at which the camera processes images, and so can have an adverse affect on burst rate. (Note: some cameras have automatic NR that cannot be switched off.)

Shutter speed and the appearance of motion

Shutter speed dictates how long the photo-sensor is exposed to light and controls the appearance of motion. A fast shutter speed (e.g. above 1/500sec) will freeze the action, giving subjects sharp, well-defined edges. A slow shutter speed (e.g. 1/10 to 1/30sec), on the other hand, will create motion blur and accentuate the sense of movement.

Of course, speed is relative and you will need to match the shutter speed to

The highlights screen

The worst possible exposure outcome in digital photography is overexposure. Overexposed or 'burned out' highlights have no value, which means, in effect, that nothing exists within the affected pixels. With no starting data, no amount of processing will recover the situation.

The highlights screen identifies areas of the image that are burned out and contain no pixel value. To check an image for overexposed highlights, activate the highlights screen from the menu during image playback. A flashing patch will show any areas of the picture where pixels have no value. Once identified, you can make subtle adjustments to exposure or apply light-limiting filters to even up the tonal range.

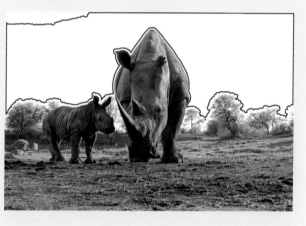

The highlights information screen provides a graphic illustration of areas of the image that are grossly overexposed.

your subject. For example, a cheetah in pursuit of its prey will be travelling at around 70mph (110km/h). At this speed, even 1/500sec is relatively slow and a shutter speed closer to 1/2000sec would be more in line. Also bear in mind that the appearance of motion will be affected by the distance to your subject and the direction in which it is moving.

When you alter shutter speed in shutter-priority AE mode, the camera will automatically reciprocate by adjusting the lens aperture by an equal and opposite amount. For example, if you increase shutter speed, reducing time of the exposure, the camera will compensate by increasing the aperture to let in more light. Conversely, a reduction in shutter speed will result in the use of a smaller aperture (i.e. a higher f-number).

Adjusting exposure with ISO

Although it can be adjusted at the beginning of a roll, it is impractical to alter the ISO rating of a roll of film midway through shooting it. However, this limitation does not apply in digital photography. ISO (the equivalent of film speed) can be adjusted for each individual frame. This makes it a more influential factor when adjusting exposure. Rather than having to adjust lens aperture or shutter speed to increase or decrease the level of light reaching the photo-sensor, you can alter its sensitivity so that it needs more or less time to record an image, as appropriate. Just beware when setting ISO ratings above 400, as digital noise can become more apparent and degrade image quality.

Histograms

Exposure used to be the 'black art' of photography, but digital capture has changed all that by introducing the histogram. The histogram is essentially a graphic representation of the brightness range of a captured image – once you have learned how to interpret it, you should rarely get an incorrect exposure. When time allows, I always take some sample images of a scene. I can then assess exposure using the histogram before I begin serious photography.

The histogram chart is easy to follow. The horizontal axis of the graph represents the overall brightness range of the photo-sensor, the far left equating to black and the far right to white. The middle of the chart is representative of mid-tone (or 18%) grey. The vertical axis denotes the number of pixels with that brightness value.

In general terms, a chart that shows a significant number of pixels on the left axis – i.e. a high proportion of pixels having a value equal to black – identifies under-exposure. Conversely, a chart that has a significant number of pixels along the right axis – i.e. a large number of pixels with the value of pure white – indicates overexposure. The ideal is somewhere in between, with some pixels in the black, some in the white and the majority in between.

In reality, the situation can be more complex. For example, an image that includes large areas of snow will inevitably produce a histogram with a significant number of pixels in the lighter zones – but this doesn't necessarily mean that the shot is overexposed. You should try to bear factors such as this in mind when assessing histograms in the field.

Field Note

A word of caution if you shoot in RAW file mode: the histogram displayed on the camera relates to a processed image and may show inaccurate data that should not be relied on entirely.

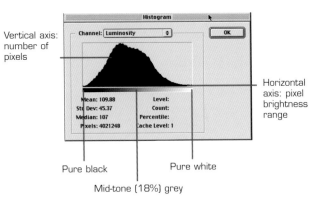

Vertical axis: number of pixels

Horizontal axis: pixel brightness range

Pure black

Pure white

Mid-tone (18%) grey

Histogram indicating underexposure

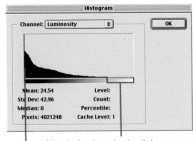

No pixel values in the lighter zones

Significant number of black pixels

Histogram indicating overexposure

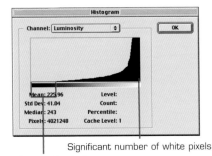

Significant number of white pixels

No pixel values in the dark zones

Histogram indicating technically accurate exposure

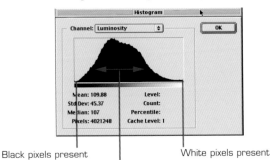

Black pixels present

White pixels present

Majority of pixels falling across the range of the grey scale

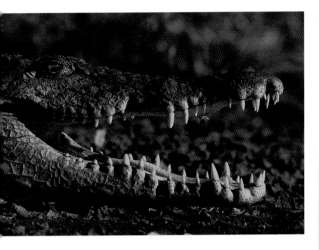

◀◀◀ **Crocodile: On checking the histogram, I found that this image was around two-stops underexposed.**

Each vertical band equates to (very) roughly one stop

△ **The vertical markers on the histogram screen provide a very rough gauge to the amount of under or overexposure.**

As a *very* rough guide, each vertical guideline on the histogram equates to around one stop. In the example on this page, I have compensated for the underexposure indicated by the histogram by increasing exposure by two stops. This has produced a well-exposed image.

▽ **Crocodile: I increased exposure by two stops to produce a correctly exposed image.**
Nikon D2H, 80–400mm VR lens set at 400mm, 1/250sec at f/5.6, ISO 200

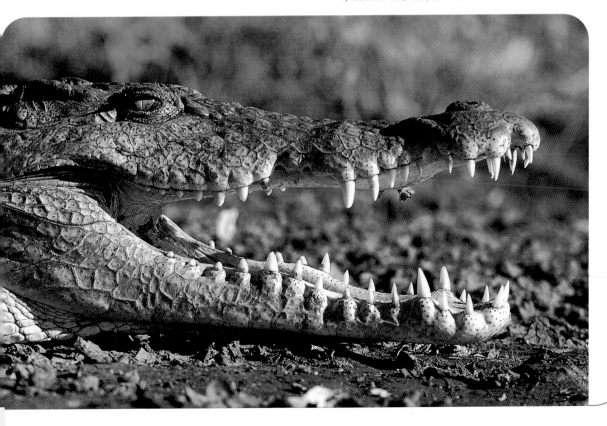

Overcoming problems in the field

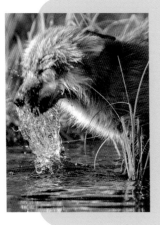

All this theory is fine, but what happens when you are confronted by a complex set of circumstances in the field and have just moments to make the right adjustments to camera settings? The following information will help you to make quick decisions in the field. Some of what follows is generic to all photographic mediums; most is unique to digital photography. However, all of it is important to taking pictures that excel.

Frame rate

The speed at which a digital camera can replenish the photo-sensor ready for a new picture to be taken is dependent on how quickly it can transfer the data from each pixel position to the memory buffer. While some of the more sophisticated models can achieve speeds in excess of eight frames per second (8fps), the majority of users will rarely need this level of performance. Most D-SLR cameras have a maximum rate of 3–4fps, which is sufficient for all but the most exacting of wildlife-photography applications.

Field Note

For action photography and when photographing unpredictable wildlife, set the shooting mode to continuous. When photographing straight animal portraits or static scenes, on the other hand, single-frame shooting will ensure that you don't waste processing time or space on your memory card by taking several identical pictures.

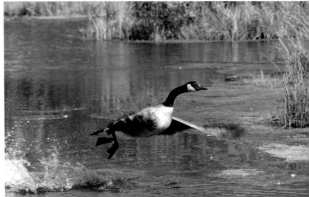

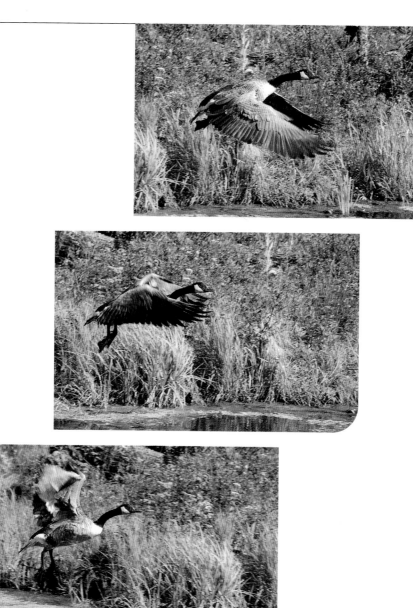

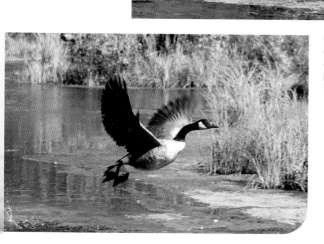

Canada goose: A high frame rate (in this case 8fps) has captured the full extent of the action of this goose as it takes flight from a pond in Minnesota.
Nikon D2H, 24–120mm VR lens set at 120mm, 1/640sec at f/8, ISO 200

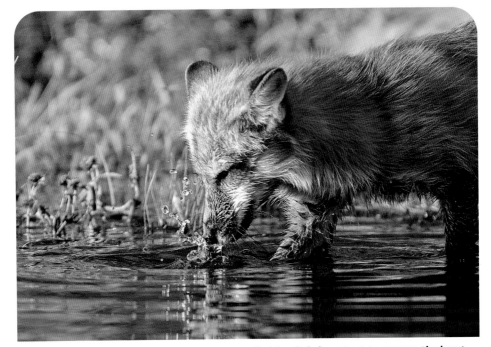

Red fox: It is important to manage the burst depth of your camera to ensure you avoid missing a compelling shot. Simply holding the shutter down in this situation would have locked the shutter at the vital moment. Instead, I paid close attention to the scene through the viewfinder and chose carefully when to fire the shutter.
Nikon D2H, 80–400mm VR lens set at 360mm, 1/500sec at f/5.6, ISO 200

Managing burst depth

My Nikon D100 had a very poor burst depth of just four RAW images, at which point it simply locked the shutter release (other cameras may just slow down, rather than locking out). This wasn't a problem when I was photographing static subjects, but caused me to miss a few good action sequences.

I have since upgraded my camera to a newer and faster model, and most current D-SLRs – even entry-level models – have a burst depth that is sufficient for general wildlife photography. However, if you find that your digital camera is locking the shutter because of a full buffer, there are a few tactics you can employ to make sure you don't miss that once-in-a-lifetime, competition-winning shot.

First, make sure that you are using the viewfinder to its full potential – really observe what is happening in front of the camera. I know this sounds like an obvious statement, but while many people look through a viewfinder, few truly *see* the scene in front of them.

Second, read the signs that all animals give when they are about to do something. This means learning to read body language and goes back to my earlier statement at the beginning of the book – that understanding animal behaviour is an essential component of great wildlife photography. For example, did you know that when a cat – of whatever size – flattens its ears, it is angry and about to take some form of action? Or, that a bird that ruffles its feathers and poops simultaneously is about to fly from its perch? This sort of knowledge will help you to know the right moment to press the shutter, rather than simply firing away in a hit-and-hope manner.

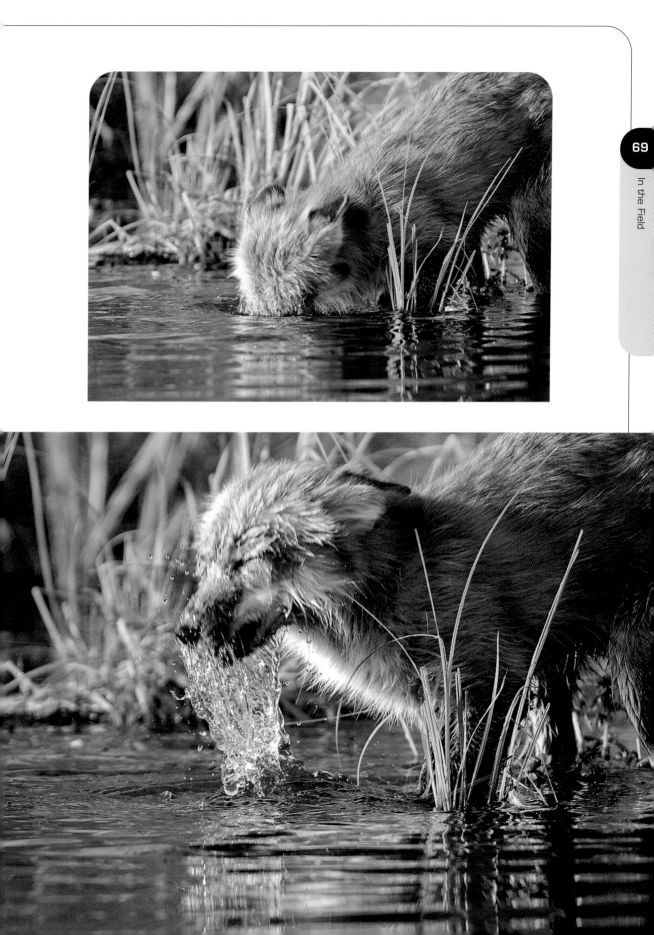

Light and white balance

The white balance (WB) sensor in a digital camera detects the colour temperature of light and, when set to automatic mode, will record it as neutral, white light. However, wildlife imagery tends to benefit from a warmer colour cast and so the automatic setting isn't always the best solution.

The majority of my wildlife images are photographed with the WB set to cloudy (or around 6000K). This setting is similar to adding an 81A or 81B filter when using daylight-balanced film, and gives pictures a warm tone that mimics the colour of light in the early morning or late afternoon.

Technique Tip

Setting the white balance

The following table shows the white balance (WB) settings I use for different subjects and conditions. Please bear in mind that these are personal preferences and are sometimes used with commercial considerations in mind. Feel free to copy them, but also experiment with WB settings to assess your own preferences.

American Black bear: Compare these two images and note how altering the WB setting has changed the mood of the picture. The lower of the two images appears warmer due to a WB setting of CLOUDY.

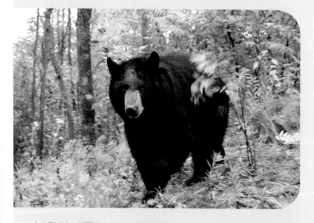

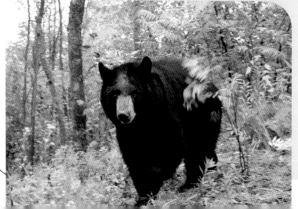

Subject	WB setting	Kelvin (K) equivalent
African wildlife	Cloudy	6000
Woodland settings (summer)	Cloudy (fine tuned)	6600
Woodland settings (autumn)	Cloudy	6000
Coast (with sea in view)	Daylight (fine tuned)	5600
Coast (without sea in view)	Cloudy	6000
Snow (sunlight)	Daylight	5200
Snow (overcast conditions)	Daylight (fine tuned)	5800
Night scenes, lit by torchlight	Incandescent	3000
Rainforests	Shade (fine tuned)	7100
Open fields	Cloudy	6000

Note: Settings may vary depending on the time of day and weather conditions.

Dust and dirt

Digital cameras are particularly prone to dust and dirt attaching itself to the low-pass (or anti-alias) filter that sits in front of the photo-sensor. Dust and dirt will block light from reaching the photo diode and cause marks to appear on your digital images. While these can be processed out using an application like Photoshop (see page 154), the process is time consuming and often difficult to master.

Prevention is better than cure, and changing lenses in dust-free environments will help. In the field, this means changing lenses in a clean plastic bag or changing bag. Alternatively, using zoom lenses will minimize the number of occasions you need to remove a lens from the camera body.

Charging batteries on the move

Digital cameras love batteries; in fact, they eat them for breakfast, lunch and dinner. I always carry at least one spare, fully charged battery with me in the field and I rarely get through two fully charged batteries in a day. However, in case I do, and for those occasions when I'm nowhere near an electrical outlet, I carry a device known as an inverter. This plugs into the 12v power outlet in cars (used for the cigarette lighter) and allows me to connect a standard three-pin plug. Using this device I can charge the batteries as if I were in the studio at home.

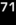

Changing bag: A specially made product like this will allow you to change your lenses in a dust-free environment, even when your are out in the field. This will help to keep your photo-sensor, and therefore your images, free from dust and dirt marks.

Field Note

If you decide to clean the sensor yourself, be very careful – you can cause more problems than you solve. Use a specialist cleaning solution and follow the manual's instructions. Never touch the sensor with your fingers or any other non-specific tool, and never use an aerosol spray. If in doubt, always take the camera to an authorized repairer for cleaning.

Changing the battery: Most D-SLRs use proprietory battery units supplied by manufacturers for their cameras.

Editing pictures in-camera

Perhaps the most groundbreaking and useful feature of digital photography is the ability to review instantly the image you've just taken, or to recall and view images stored on the memory card. I know that some people view this as cheating, but to me that view seems naive. After all, haven't photographers been using Polaroid film for exactly the same purpose for decades?

Whatever your feelings on the subject of instant playback and review, this function will greatly increase your productivity in the field. It will make experimenting with new techniques far more rewarding and, ultimately, more successful.

Using the LCD

When reviewing images on the screen you should be checking predominantly for composition and sharpness. Make sure you check all corners and edges of the picture space, and the background for eye-catching clutter that you may have missed. These could include unwanted distractions such as a brightly coloured berry in a corner of the frame, litter on the ground, or an electrical pylon slap-bang in the middle of the picture. When reviewing focus, use the magnification tool to zoom in on the eyes and confirm they are pin sharp.

Exposure is difficult to assess by looking at the on-screen image alone, so call up the histogram (see page 64) for a more accurate indication of exposure. In brightly lit scenes where there is an extreme range of tones, remember to review the highlights screen (see page 63) for any areas of the picture that may be burned out.

Colour, in particular, is difficult to gauge on the LCD screen and is better left until you have access to a computer, as is tone. Both of these settings can be altered later in-computer if the image was saved as a RAW file.

Scrolling through the shooting information will tell you exactly what exposure settings were used and will help you make subtle adjustments when experimenting with new techniques. For example, if you are photographing a bird in flight and the resulting images are coming out blurred, check the LCD for information on the shutter speed used. If it is too slow, this is likely to be the cause of the blur, rather than incorrect focusing or camera shake.

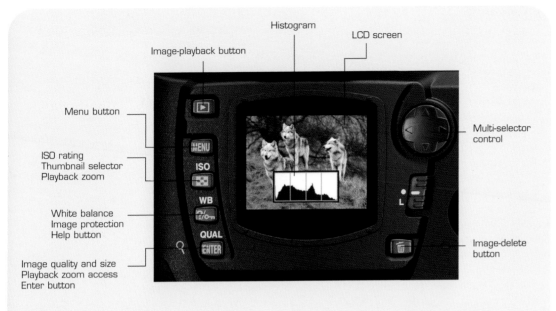

Histogram

LCD screen

Image-playback button

Menu button

ISO rating
Thumbnail selector
Playback zoom

White balance
Image protection
Help button

Image quality and size
Playback zoom access
Enter button

Multi-selector
control

Image-delete
button

Image playback and review options can generally be accessed via the camera's menus or by using the function buttons located on the rear of the camera body. While menu structures and button types/layouts vary widely, most D-SLRs offer similar options. Useful functions include: a zoom/magnification tool that helps you to assess image focus; a highlights screen that shows overexposed areas; and, as shown here, a histogram that aids the assessment of exposure.

Equipment

Screen shades

The LCD can sometimes be difficult to view properly, particularly in bright conditions where light is reflected by the screen. Some camera manufacturers are trying to improve the situation. For example, Olympus have produced a 'Sunshine LCD', which uses semi-transparent layers to allow the sunlight to penetrate a few layers into the panel and present a much brighter image.

An alternative solution is to buy a screen shade, various types of which are available commercially from photographic retailers. However, these items can be vulnerable to damage when used excessively, and so must be treated with care in the field. A cheaper option is to use the cardboard tube from a roll of toilet tissue. It works almost as well, costs nothing and can be folded flat and carried in your back pocket.

Editing in-camera

Something you will find having switched to the digital medium is that you will take far more pictures than you used to. For instance, a friend of mine who travelled with me on one of my photographic safaris shot over 10,000 images in just two weeks. The problem is, all those images take some managing! Rather than spending hours sitting at your computer, one option is to do some initial editing in the field using the camera itself.

One method of managing images in-camera that I have found particularly effective is to create new folders for different subjects or assignments. New folders can be created via the menus, usually the set-up menu (see your camera's manual for details). Menus can then be divided into subject name, location or another identifying tag to help image management in-computer.

Storing images out of the camera

Even with some of the larger-capacity memory cards, there will come a point when you are working in the field and want to store digital files out of the camera. The obvious solution is to transfer your images to a laptop computer, but this involves carrying a (relatively) heavy, delicate piece of

Field Note

Reviewing images on the LCD screen is draining on batteries. Switch off the automatic playback function via the menu and only review images in the field when necessary, to save on battery power.

technology around with you and subjecting it to the rigours of fieldwork – and you already have your camera to worry about! It also means having to own a laptop in the first place, which is an expense you may wish to avoid. There are two alternatives:

Portable hard disk drives (HDD)

These palm-size devices are, literally, a hard drive that you can carry around with you easily. Disks with a capacity of 80gb or more are available, and they

Field Note

I would advise deleting any obviously poor images before you download them to a computer or portable storage device. However, if you have a particularly compelling shot, make sure you protect it from accidental deletion by pressing the image-protect button on the camera back.

A portable HDD. These devices can be used in the field to store images from a memory card.

can store several thousand images. Many models also have a small LCD screen to help with editing in the field. Although these screens suffer from some of the same problems as the LCD screen on your camera, they do tend to be a little larger.

The main disadvantage is reliability. In particular, an HDD is a mechanical device and so has moving parts. Having said that, I have used these devices in the field regularly and have yet to have one fail on me.

Portable CD writers

Slightly larger than a portable HDD, these work by burning the files from your memory card directly onto a CD. One advantage with this device is that you don't put all of your eggs in one basket. Also, once the images are on CD, they are fairly safe. On the other hand, they do require that you carry a number of blank CDs around, and with a limited capacity (around 700mb) that could be quite a lot of discs.

Field Note

If you are of a particularly paranoid disposition, you can download your images to a portable HDD and then copy them to CD to be doubly safe. I have been known to do this on more than one occasion – it may sound like overkill, but at least I slept at night!

An alternative solution to storing images on the move is this portable **CD writer**. These devices also provide a secure and useful means of backing up data in the field.

Red fox (Vulpes vulpes)

Locations:

Arctic, North America, Europe, Asia, North Africa and Australia.

Habitat:

Temperate forest, including woodland; mountains; desert and semi-desert regions; polar regions; urban areas.

The Red fox is widespread throughout most of the world and is considered a pest by many people, particularly farmers who lose small livestock to this capable predator. On the other hand, they are a beautifully photogenic creature, with fur that ranges in colour from grey to rust red and, sometimes, almost orange. Their success as an animal is due, in part, to their adaptability, and today you are as likely to spot a fox in the city centre as you are in the countryside.

Best location for photography: with a little patience and some encouragement in the form of food, your own back garden can be a good place to photograph foxes. Otherwise, set up a semi-permanent blind in local woodland where fox presence is known and use bait to entice resident foxes to your position.

Best time of year for photography: Pups are born in April or May and will emerge from the den after about four to six weeks. Foxes can be photographed at any time of the year and, compositionally, summer greens interact well with a fox's red coat.

Patience was the key to this picture. It took a while for the fox to accept my presence, but once he realized I was of no threat, he went about his business blissfully apathetic to both me and my camera. ▶▶▶
Nikon D2H, 12–24mm lens set at 14mm, 1/1000sec at f/6.7, ISO 200, Nikon SB-800 i-TTL flash

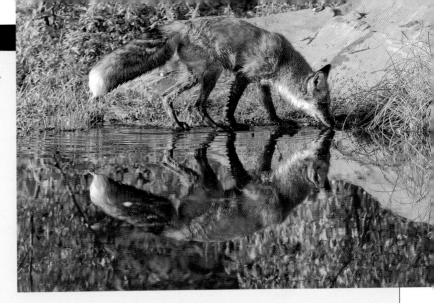

ortune favours the patient. After several
mornings spent with this subject, the
ight and weather conditions finally came
ight to capture this perfect reflection.
*Nikon D2H, 80–400mm VR lens set at
35mm, 1/500sec at f/5.6, ISO 200*

Shots to look out for: interaction
between mother and cubs during late
spring and early summer; interesting
juxtapositions of fox and environment,
particularly humorous events.
Specialist equipment needed: a blind (to
get closer to the animal than you'd be
able to if stalking in the open); a good
flash set-up (because foxes are also active
at night); remote-control photography is
another feasible option.

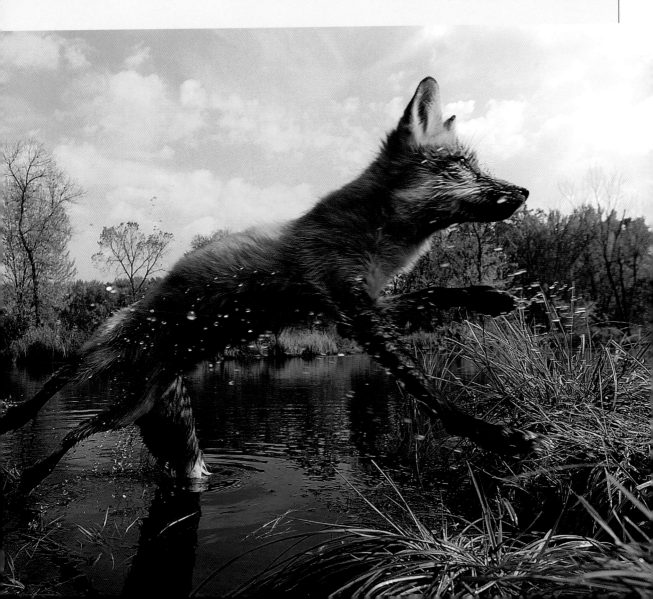

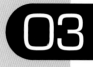

Taking Wildlife Pictures

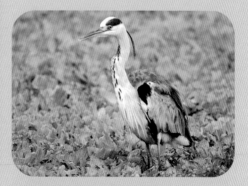

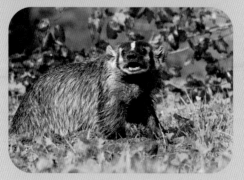

Close to home

All this theory about cameras and their functions is all very interesting, but what you really want is to be outside taking pictures! Your first difficulty is finding a subject to photograph. The problem is that most wildlife subjects aren't too happy in the presence of humans. Many scurry or flap away as soon as they smell or hear us – and who can blame them.

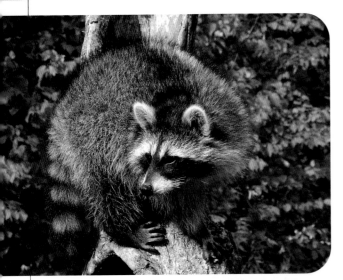

I appreciate that it's less than exotic, but the best place to begin taking pictures of wildlife is in your own back yard, particularly if you live in or near the countryside. Even in an urban environment, you would be surprised at the quantity of wildlife around you. Given a little patience and a helping hand, garden wildlife photography can be as rewarding as an overseas adventure.

◀◀◀ **Racoon: Mammals, such as this inquisitive racoon, will happily return to gardens where they know food is present, providing the patient wildlife photographer with many hours of happy snapping.**
Nikon D2H, 24–120mm VR lens set at 40mm, 1/180sec at f/11, ISO 200

Aylesbury ducks: ▶▶▶ **Although your own back yard or local neighbourhood is not the most exotic of locations, it is far easier to gain an intimate knowledge of, and this will lead to some great photo opportunities.**
Nikon D100, 800mm lens, 1/350sec at f/8, ISO 200

◄◄◄ **Set up a feeder with a natural-looking perch to attract birds to your garden.**

Set up feeding stations and nest boxes in visible but protected areas of your garden and be certain to keep them topped up regularly. Nuts and seeds are a firm favourite with most garden birds, and winter is the best season to begin feeding because food is scarce in the wild. Also, lay out fruit on the lawn for some of the larger bird species, such as thrushes. Most fruits are suitable, although you will find that apples make an excellent choice. Not only do birds like them, they are also colourful and add to a picture's composition.

If you are lucky enough to have mammals visiting your garden, leaving out the appropriate type of food will keep them coming back for more. Like most animals, mammals will be wary at first, but keep the free meals coming and they soon lose their inhibitions.

Think about what time of year it is and how this might affect the types and activities of subjects. Spring is the start of the new year for wildlife; it is a time of intense activity as nature awakens from her winter sleep. For many species this is when courtship and nesting begins, while for others newborn cubs are emerging from dens. Summer is a time of growth, while autumn sees migratory birds in the north head south for warmer climes. Winter is when nature rejuvenates and animal activity slows down, but it is also a time when animals are at their least defensive as they forage for food that is in short supply.

Field Note

If you begin feeding wildlife in the winter, you must continue through the season until spring. Animals will come to rely on your bait as a food source, and could starve if feeding stops abruptly.

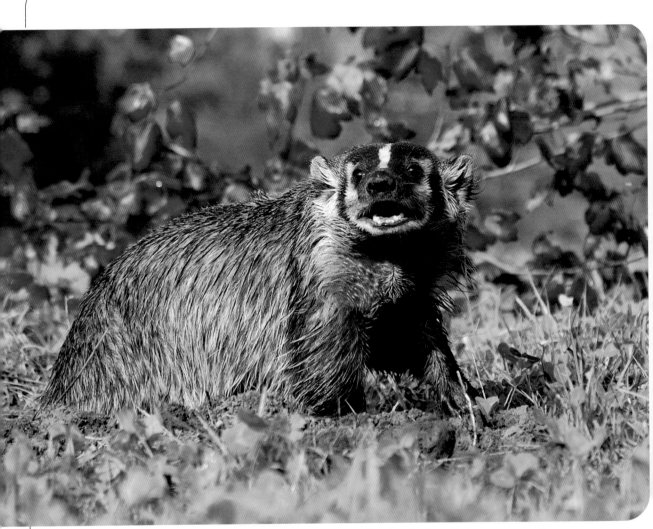

American badger: Badgers are a regular visitor to gardens and are easily photographed from a well-positioned hide.
Nikon D2H, 24–120mm VR lens set at 65mm, 1/160sec at f/5.6, ISO 200

Field Note

As well as laying out food, set up props that will enhance the natural look of your pictures. A tree branch set in the ground will attract birds to perch on it. Where the natural backgrounds are unsightly, build a framework of colourful foliage that you can prop up with a wooden stake or against a fence.

Garden hides are a quick and simple way to begin wildlife photography. If set up a few weeks before intended use, this will ensure that wildlife becomes familiar with the hide's presence.

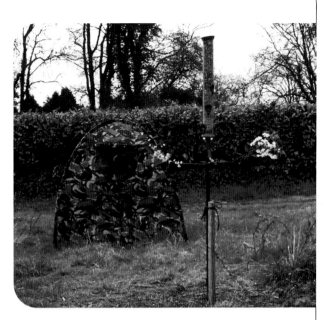

Garden hides

When it comes to photography you have two main choices: you can either photograph from a hide or you can use a simple remote-control set-up. If and when the wildlife becomes used to your presence, you may even get to photograph it without the need for either.

The best form of garden hide is your own home. Pick a doorway or window that has a clear view of your subjects and cover it over with camouflage netting. Then attach your camera to a tripod and simply sit and wait. It's best to keep your photography to a time when the house is empty of other people so that you can minimize the level of noise and movement. I'd also recommend a comfy chair – you may be there for some time.

The main advantage of this type of hide over a field hide is that you can get up and move around without compromising your position. Alternatives to your house are sheds, glasshouses and even a kid's playhouse, if it's not too cramped! Another option is a canvas hide, either homemade or a commercially available model. If you follow this route, set up the hide a few days in advance so that the animals can get used to its presence.

The disadvantage of using a hide other than your house is that once you are in it you are pretty much stuck there until you have finished shooting. Take along some refreshments and a bottle for relieving yourself. This way, you will find life a good deal more comfortable. Once in the hide, be careful not to broadcast your presence to visiting wildlife. Unless you are quiet, you will find potential subjects making a beeline for the neighbour's yard.

Camouflaged netting will help to obscure your presence but allow you an all-important view of your subject.

Field Note

If you are planning on using equipment that will be in open view, set up some dummies a couple of weeks prior to commencing your photography so that the wildlife can get used to it. Replace the dummies with the real thing on the day of your shoot and at a time when no wildlife is present.

Simple remote-control set-ups

When working in the garden, an alternative to setting up a hide is to use a simple remote-control set-up. This is particularly effective when you know exactly where the subject is going to be, and can be used to good effect with, for example, birds on perches.

Once again, you will need to construct a dummy prior to taking any pictures so that the wildlife has time to get used to the new contours of their environment. I often position my tripod camouflaged in leaf-covered branches, which means I only have to add the camera when the time comes to photograph.

To take the picture, set the camera to manual focus and focus on the point where you anticipate the subject will be. To give yourself a little leeway, if the light is bright enough, set an aperture of around f/11, which will increase depth of field. Be careful to ensure that the background is far enough away to render it out of focus.

I tend to set the metering to multi-segment in aperture-priority mode, which, having set an appropriate lens

▲ A simple remote-control set-up can help you get close to animals for frame-filling images without needing to go to the extent of setting up a garden hide. This set-up was used to photograph foxes in the wild.

aperture, I've found to give perfectly good results most of the time. It is sometimes worth switching on the auto-bracketing function (see page 60) on the camera to around ±$^1/_2$ stop, just to be sure.

Technique Tip

Successful remote-control photography
Here are some guidelines to help you ensure that you get the results you are looking for from your remote-control set-up:

❑ Bracket shots to ensure accurate exposures and/or shoot RAW files to facilitate post-capture processing.

❑ Set the frame advance to continuous to make capturing action shots easier.

❑ If using infrared remote control, make sure there is a clear line of sight between the transmitter and the receiver.

❑ Use a large-capacity memory card to ensure you don't run out of space too soon, and ensure that the camera batteries are fully charged at the beginning of the shoot.

❑ It may sound obvious, but make sure you have switched on the camera before leaving it in place.

An electronic remote cable release can be used to trigger the shutter when using the camera remotely.

Field Note

Take some time to try to get to know the staff at safari parks. After a while you may find that you are given access to areas not normally open to the public, or out of hours when the area is quiet. Always be polite and follow any instructions given.

To fire the shutter, attach a remote shutter-release cable, fitted with an extension if necessary. Alternatively, if you need to be further away, an infrared remote control will work equally well up to a distance of around 100ft (30m).

Photographing animals in captivity

If finding wildlife in the wild is proving difficult, another great place to begin taking pictures of animals is at a safari park or zoo. The advantage of this approach is that you are guaranteed to see animals, with some of them being the more exotic species. The difficulty is in making the pictures look natural.

To cut out distracting backgrounds, such as fences, cars and people, use a telephoto lens to reduce the field of view and set an aperture that will give you a narrow depth of field. Also, look out for behavioural aspects that will lend your images a greater visual presence. Humour, interaction, action and emotion are all attributes that make wildlife photographs more compelling (see page 105).

Cheetah and Persian leopard: Compare these two images of big cats in captivity. The picture above was obviously taken at a zoo or safari park, while this is less obvious in the image on the right. When photographing captive wildlife, try to compose the shot in a way that creates more natural-looking pictures.

Technique Tip

Photographing into enclosures

When shooting through wire, use a telephoto lens and set it to its maximum aperture. Position the lens right up against the mesh, making sure that the centre of the lens is unobscured (you may also want to use a UV filter to protect the front element). The wire will become so far out of focus that it will disappear altogether. When shooting through glass, again, position the lens directly against the surface to minimize any reflections. When using flash, this technique will also prevent the flash creating a bright spot where it reflects off the glass surface.

Vervet monkey: I'm not a big fan of photographing animals in captivity, but sometimes you can create compelling images with a strong message. The winning entry in the 2003 Wildlife Photographer of the Year competition was a particularly powerful photograph taken in a zoo. *Nikon D2H, 24–120mm VR lens set at 80mm, 1/25sec at f/4.5, ISO 200*

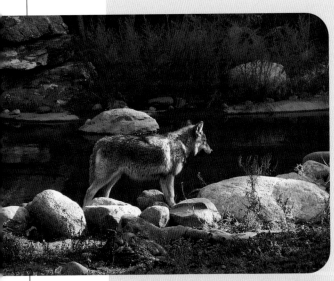

Grey wolf: When photographing wildlife through glass, place the lens right up against the surface (above) to avoid reflections (right). *Kodak DX7630, 24mm, 1/125sec at f/4.8*

Animal portraits

Most photographers' first steps in wildlife photography start with animal portraits. The techniques are easier to learn and master than other forms of wildlife photography, but are just as important for successful results.

First, decide on the format that best suits your subject: vertical or horizontal. Some animals lend themselves to one particular format or the other. For example, a giraffe may be photographed best in the vertical format, while a portrait of a cheetah will often benefit from being taken in the horizontal format. However, there are no strict rules.

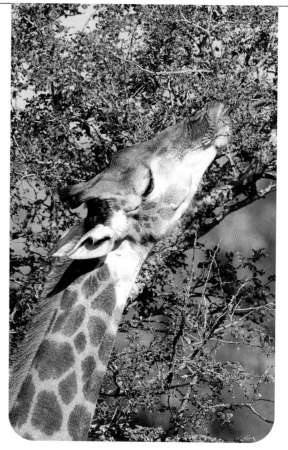

Giraffe: This photograph benefits from the ▶▶▶ **vertical format, which accentuates the height of the animal.**
Nikon D100, 800mm lens, 1/250sec at f/8, ISO 200

▼ **Cheetah: A horizontal format has helped to create a sense of place in this image. The vertical format would have lacked impact.**
Nikon D2H, 300mm lens with 2x teleconverter (600mm), 1/640sec at f/5.6, ISO 200

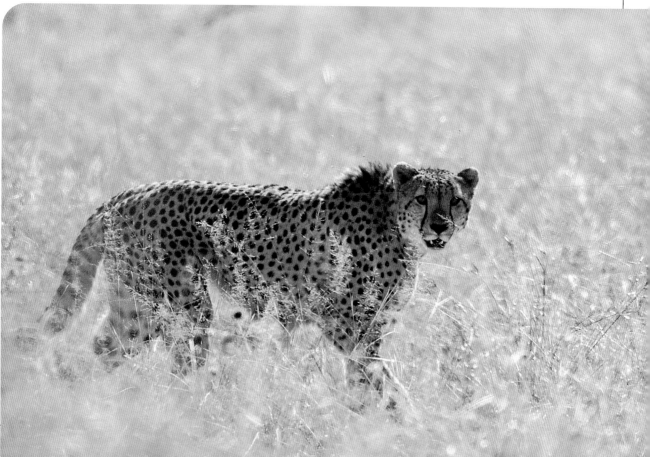

When focusing, make sure that the eyes form the point of focus. The most important part of any animal to be pin-sharp is the eye. It is the first thing we look at when we view any portrait, animal or human. The second most important feature to get sharp is the nose, which isn't always as easy as it seems. For animals with long snouts, such as bears and wolves, you'll need to set an aperture at least one or two stops smaller than the maximum aperture setting (e.g. f/4 or f/5.6 instead of f/2.8). If you have to compromise, however, then sacrifice the nose – it's always eyes first.

To accentuate the subject, you will need a shallow depth of field to render background detail blurred. For this reason, animal portraits are often best taken using a telephoto lens. A wide aperture will also help to blur background detail.

Good light is the other key factor to a successful animal portrait. Lit from the front or directly above, your subject will lack form and the picture will appear flat

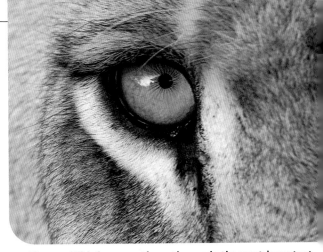

Lioness: With few exceptions, the eye is the most important feature of an animal to get sharp. It is the first thing we look at when we see a portrait photograph of an animal (or a human, come to that).
Nikon D2H, 80–400mm VR lens set at 400mm, 1/40sec at f/11, ISO 200

and uninspiring. Light coming from an angle of around 45 degrees and low to the horizon will create areas of beautiful contrast and lend pictures a three-dimensional aspect. In very bright conditions, you may want to think about using a burst of fill-in flash to lighten harsh shadows (see page 128).

American badger: A shallow depth of field will help to isolate an animal from its environment, removing any distracting background elements and helping to focus attention on the subject.
Nikon D2H, 80–400mm VR lens set at 300mm, 1/200sec at f/5.6, ISO 200

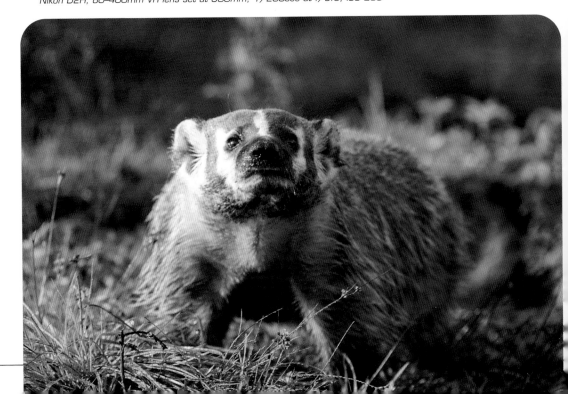

Lion: Capturing animal behaviour within a wildlife portrait will help to distinguish your images from the staid, 'passport-like' pictures that are all to easy to achieve. When taking this image of a lion cub in South Africa, I had to wait several moments for the yawn – but it was worth waiting for.

Nikon D2H, 300mm lens, 1/350sec at f/8, ISO 200

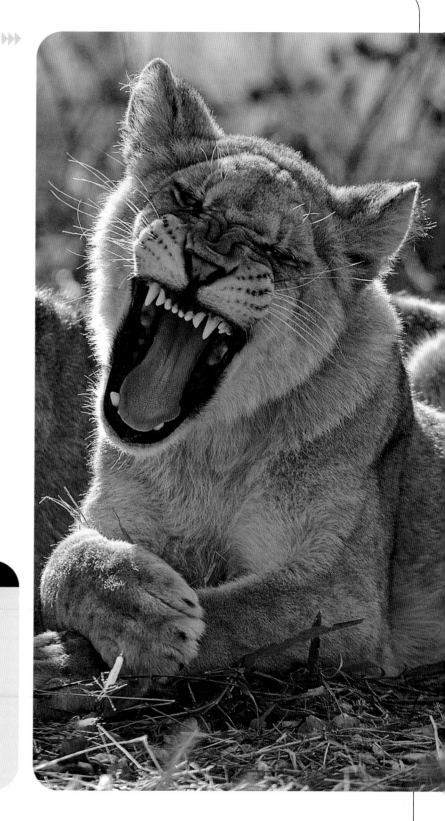

Field Note

To stop your animal portraits from looking like passport photographs, wait until the animal shows some aspect of behaviour. For instance, yawning, snarling, licking the lips or fur, and rubbing eyes with paws would all add some visual weight to your pictures, giving them an extra dimension.

Approaching wildlife in the field

Good preparation will make any field trip easier and greatly improve your chances of success. However, away from your back yard animals are likely to be more nervous and less approachable. This can make finding wildlife even more of a challenge: if it doesn't want to be seen, you can be fairly certain you won't find it easily.

▼ Cheetah: This is a typical view of wildlife as seen through my viewfinder! Approaching animals in the wild takes skills learned over time. However, an intimate knowledge of field craft is as important to successful wildlife photography as sound photographic and camera technique.
Nikon D2H, 300mm lens with 2x teleconverter (600mm), 1/1250sec at f/5.6, ISO 200

Seek out wildlife experts in your local region who may be able to help you in locating wildlife subjects for photography. Wildlife trusts and conservation organizations, the US Fish & Wildlife Service, as well as biologists and field researchers, all have information that is valuable to wildlife photographers. The internet is a great source for contact details.

Field craft and biology may not come naturally to you, and it takes time to develop the necessary skills to be proficient in either. However, here are a few tricks that will help to get you started.

Careful choice of clothing is essential for a successful stalk. Because most animals have a pronounced sense of hearing, the right type of material is as important as the colour. ▶▶▶

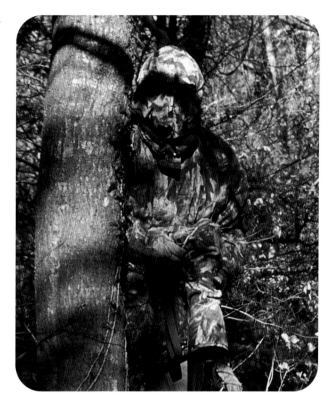

Animal tracking and stalking

When setting out on a track or stalk, the first thing to think about is the clothes you intend to wear. Camouflage outerwear is useful but not essential – natural colours, such as green, brown and beige work equally well in most situations. More important than colour is the material the clothes are made from.

The two main senses of most mammals, for instance, are hearing and smell – not vision. Camouflaged or not, a mammal is more likely to hear or smell you well before it ever sees you. Therefore, wear clothing made from natural fibres, such as cotton and linen, to minimize sound when moving. Openings should be zippered; avoid Velcro, which is noisy. Carry no heavily scented items, such as food, and avoid wearing deodorant or perfumes. If you want to go all out, camouflage your smell by rolling in the undergrowth around you.

Carry a minimal amount of equipment and make sure any packs are secured around your body. You will find it easier to work with lightweight gear than big, heavy lenses, so consider using smaller, lighter lenses. The narrower maximum aperture of such lenses can be a problem when photographing in dense woodland or forest, where the canopy restricts the level of light on the ground. Where this is the case, consider using a more sensitive ISO rating, such as 400.

When walking in wooded areas, check the path underfoot and avoid treading on twigs – these can snap easily, giving away your location. Look out for the telltale signs of animal presence, such as footprints, broken or trampled foliage and fresh droppings (they are the steaming ones, in case you are unsure!)

Equipment 📷

Gear guide

If you saw all the kit I take along as a professional wildlife photographer on assignment, you would be forgiven for thinking I was heading off on some sort of military expedition. There are reasons I carry so much gear, but you can start taking successful wildlife images even with a rudimentary amount of equipment. Here is my recommendation for a simple kit bag:

Camera body	Any interchangeable-lens digital SLR
Lenses	Wideangle AF zoom (e.g. 17–35mm) Telephoto AF zoom (e.g. 70–300mm) 1.4x or 2x teleconverter
Digital accessories	1gb memory card
Other accessories	Tripod with ball-and-socket head Cable release Beanbag Small flash unit

Once you are on the right trail, always approach an animal from down wind, even if this means making a long detour to change your angle of approach. I once watched a cheetah circle a mile to get down wind of a herd of zebra before going in for the kill, so take a lesson from the experts.

◀◀◀ **Cheetah: Stalking is best learned from the experts. I watched this cheetah circle a mile to get down wind of its intended prey, a herd of zebra, before making its sudden but silent move. Even then, the zebra got away!**
Nikon D2H, 24–120mm VR lens set at 120mm, 1/125sec at f/5.6, ISO 200

In open ground, where masking your presence isn't really an option, I have found that nonchalance is the best form of camouflage. The trick is to make (very) slow progress towards the subject without making eye contact or acknowledging its existence in any way. However, be prepared to be disappointed. This technique takes great patience and often ends in failure – sometimes through no fault of your own.

Understanding the circle of fear

All animals have a space around them that is known as their circle of fear; breach it and they flee. Getting within this circle is the name of the game, and understanding animal behaviour is key to making progress. Better still, be patient and let the animal come to you.

The extent of the circle of fear varies depending on the species of animal, the characteristics of an individual subject, escape routes, time of year, and so on. For example, wading birds such as herons and Sandhill cranes have a very wide circle of fear and will fly off if you get within several hundred yards of them. Some garden birds on the other hand will let you come within arm's reach, given a little patience. In areas of prolific hunting, most animals keep a wary distance from humans, while in regions where man is uncommon – the Antarctic, the Galapagos Islands – they wander over to greet you with idle curiosity.

Grey heron: All animals have a circle of fear, which, when encroached upon, causes them to flee. The extent of this imaginary circle varies depending on many different criteria. For some, such as this Grey heron, it is particularly wide, making good photography all the more difficult.
Nikon D100, 800mm lens, 1/160sec at f/5.6, ISO 200

Using blinds

You can easily spend an entire weekend in search of wildlife and never find it – trust me, I've been there and beyond! An alternative solution is to get the wildlife to come to you. Not only is this approach easier on the feet, it breaks down the invisible barriers that exist between you and the subject, which will lead to far more intimate photographs.

A dome-type blind, such as the one shown here, can be erected and collapsed quickly and easily.

As can be seen in these two images, larger blinds have more room for extra cameras and accessories, which can be set up for different shooting opportunities and conditions.

Setting up a blind is a great way to start. Ready-made blinds, such as dome blinds, are available commercially from specialist suppliers, or you can build your own. Unless you plan to photograph from the same spot regularly, a portable, ready-made variety will likely be your most versatile option.

For wildlife photography from a blind to be successful, the structure must be set up – or a dummy placed in position – at least a few days, and preferably two or three weeks, prior to use. Animals are perceptive, and territorial animals know their patch intimately. They are going to be very wary of any new landform suddenly appearing in their environment and will stay away until certain there is no threat.

Enter the blind when there is no wildlife activity – before sunrise is best. Once in the blind, make sure everything is to hand and accessible without causing a disturbance. Get your camera set up quickly and noiselessly and minimize your own activity within so that you don't disturb any nearby creatures. Your camera should be set up on a tripod with the right lens attached (you really don't want to be changing lenses while in the blind). If you have a spare camera, attach a shorter focal length lens, preferably a zoom-type, and keep it handy for those

times when the wildlife ventures closer than expected. If you plan to be around for most of the day, take some food and water for refreshment, and a container so you won't have to mark your territory – so to speak. When you leave the blind, make sure you do so with the same care that you entered it and when there is no wildlife activity.

To encourage wildlife to your blind you can set up a feeding station in much the same way as you would for your garden, (see page 83). You may have to keep the food topped up over a period of time, particularly if the area isn't within a natural territory. During winter months, the same rules apply as for your garden. Food, once provided, must be kept available until spring.

Technique Tip

A helping hand

If you are attempting to photograph birds from a blind, you may need a companion to enter the blind with you and leave momentarily. Far from their 'birdbrain' tag, many birds are very intelligent and nearly all birds have fantastic eyesight. If they notice you enter the hide they will wait for you to leave before approaching. If they see your companion leave they will assume that you have left and continue with their normal routine. Be aware, however, that some of the more intelligent birds – such as crows, hawks, eagles and falcons – can count, and you may need more than one helper!

Technique Tip

On the move

Cars make excellent mobile blinds. The colour of your vehicle really doesn't matter, but the same rules of setting up a blind apply. Make sure you arrive early and have everything prepared before the wildlife is likely to become active. To conceal your presence, cover the window you are photographing out of with some camouflage netting that is attached securely. Use a beanbag or a specially designed window tripod to support the camera. The engine and radio should be turned off and smokers should refrain from lighting up – the smell of the cigarette will give you away.

Designing a photograph

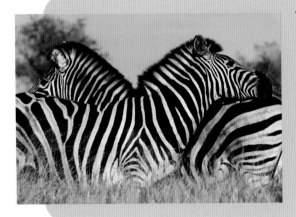

The difference between taking a picture and making one goes much further than a single letter in the alphabet. Great wildlife photographers know instinctively how to manage the picture space and how to marry the elements of design to intensify visual presence.

Unlike artists, who begin with a blank canvas, photographers are presented with an 'already-painted' scene. Rather than accept what you see as the only picture, however, your role is to determine which pictorial elements within that scene are important to the message you are trying to portray. You must then use the photographic tools and techniques at your disposal to isolate key subjects and remove clutter. In this respect, if a painting is defined by what the artist chooses to add in, a photograph is defined by what the photographer chooses to leave out.

Subject positioning

When your subject is centred in the frame, visual weight is placed on the subject and the surrounding detail becomes a secondary consideration, which is entirely appropriate if that is the aim of the picture. In this instance, the extent of the relationship between animal and human becomes far more intimate and compelling.

Depth of field will also affect the accent placed on an image. A shallow depth of field, where foreground and background detail is blurred, will place the emphasis on the subject. The opposite approach (using a small aperture to ensure a large depth of field) will lend equal weight to the subject and its environment, creating a sense of place.

African elephant: A central composition like this can make a dramatic visual statement, where all the emphasis is placed on the subject rather than on any peripheral details.
Nikon D2H, 24–120mm VR lens set at 48mm, 1/1000sec at f/8, ISO 200

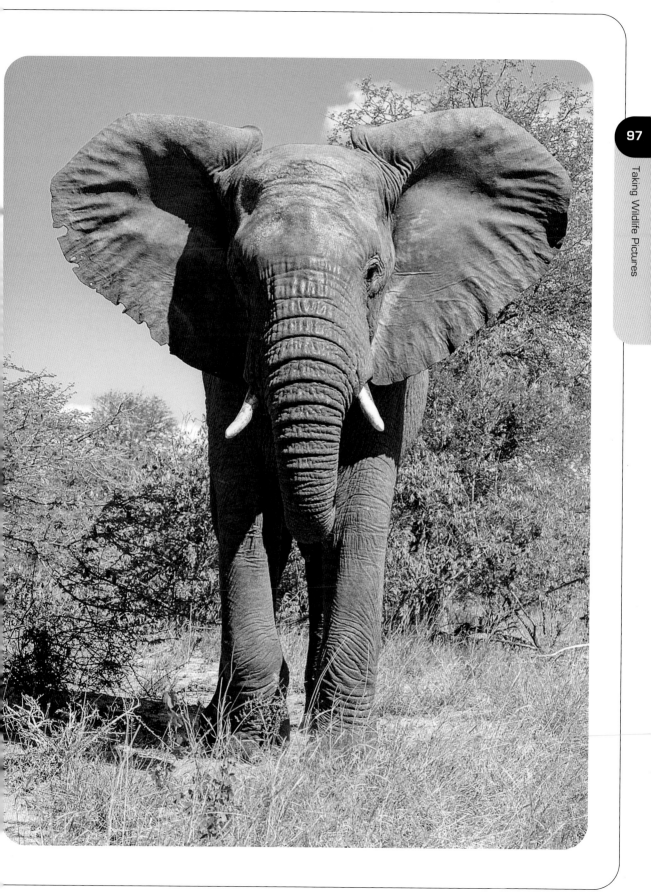

Technique Tip

The rule of thirds

An often-used and successful compositional tool is the rule of thirds. This works by dividing the picture space into thirds, with imaginary lines drawn one-third of the way in from each side and from the top and bottom. The idea is that maximum visual impact will be achieved by positioning the subject at the point where two lines meet.

Using the rule of thirds places a different visual weight on the image and opens up the picture space to competing pictorial elements. As a result, it can be used successfully when photographing a subject within its environment.

Klipspringer: The rule of thirds is more closely associated with landscape photography, but can apply equally when photographing wildlife.
Nikon D2H, 300mm lens with 2x teleconverter (600mm), 1/160sec at f/8, ISO 200

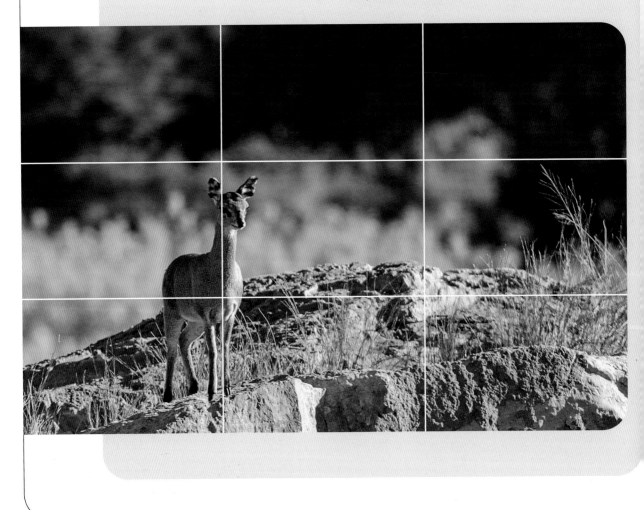

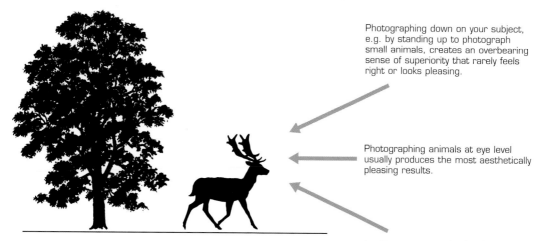

Photographing down on your subject, e.g. by standing up to photograph small animals, creates an overbearing sense of superiority that rarely feels right or looks pleasing.

Photographing animals at eye level usually produces the most aesthetically pleasing results.

Looking up to an animal makes it the dominant subject, which can accentuate our feeling of vulnerability with dangerous predators, such as big cats, bears and wolves.

The angle from which you photograph an animal will directly impact the way the viewer perceives their relationship with the subject, as this diagram illustrates.

Choosing your viewpoint

The angle at which you take the picture will influence the extent of the relationship between the viewer and the subject. When we look down on a subject we portray a sense of power over it – much like the parent/child relationship, where children are considered to be subservient to adults. Conversely, when we are looked down upon we become the subservient subject. At eye level, the relationship is one of equality, neither party having power over the other.

You should consider these dynamics when deciding on your shooting position. Many animals, small mammals in particular, are much smaller than we are. If you photograph them from a standing position, you will be creating a negative dynamic between the subject and viewer that is rarely appealing.

Three-banded plover: To illustrate the impact of using different viewpoints, I photographed this plover while standing in an open jeep. The high camera position has created an unappealing composition. *Nikon D2H, 300mm lens with 2x teleconverter, 1/125sec at f/8, ISO 200*

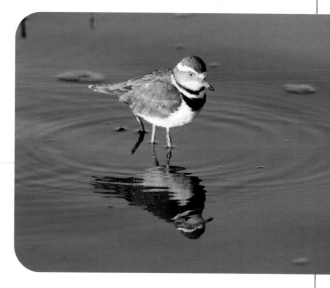

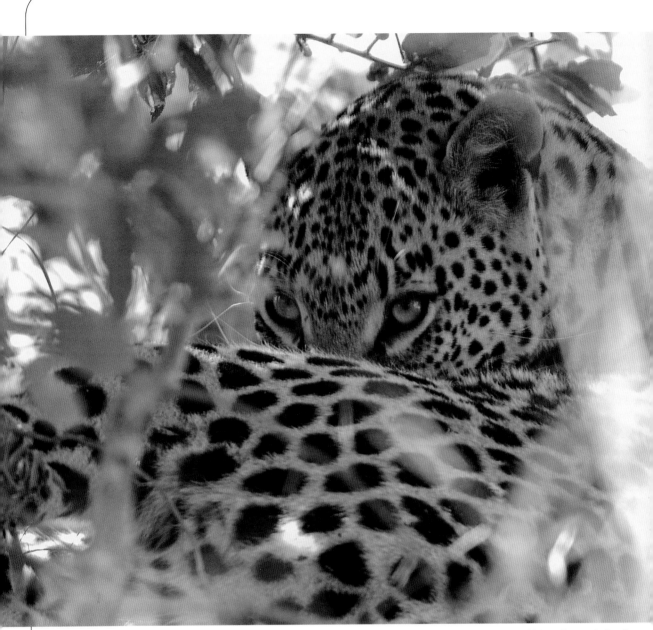

Field Note

For a more pleasing image, keep low down and photograph animals at eye level. For tall subjects, or when photographing birds in trees, you need to raise your position in order to maintain eye-level contact.

African leopard: Getting down to the subject's eye level gives your images a far more powerful composition and changes the relationship between the photographer/viewer and the subject to one of equality – although I didn't feel all that equal to this young male leopard!
Nikon D2H, 80–400mm set at 400mm, 1/60sec at f/8, ISO 200

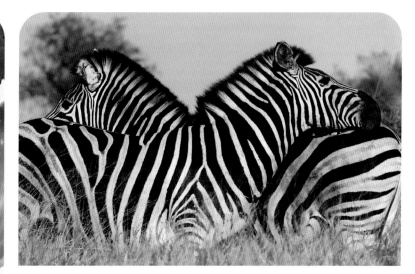

Plains (Burchell's) zebra:
A symmetrical design creates balance and a sense of well-being. Compare this image that below and note how my choice of composition alters visual impact.
Nikon D2H, 300mm lens with 2x teleconverter (600mm), 1/250sec at f/16, ISO 200

Creating energy and form

Another consideration when taking images with that something extra is visual energy. By their very nature, photographs are two-dimensional, static objects. Unfortunately, this state doesn't lend itself to compelling pictures. As the photographer, your job is to create images with energy and form.

A symmetrical picture design will add to the feeling of stasis, as it creates a sense of well-being and calm. Conversely, an asymmetric design will create dynamism and add visual energy because it makes us feel off-balance.

Plains (Burchell's) zebra: Here, I have used an asymmetric composition to add visual energy to an otherwise static situation.
Nikon D2H, 300mm lens with 2x teleconverter (600mm), 1/160sec at f/16, ISO 200

Colour

Colour is another powerful visual tool. Pastel colours are soothing and soften the visual impact of a picture; bold colours, such as red and blue, clash and create a dynamic intensity. Using two complementary colours together in the picture space, particularly red and green, also increases visual energy. This is because their different wavelengths cause our eyes to shift focus.

Line

You may not consider the basic elements of design when taking photographs, but isolating or highlighting them within the picture space can improve the compositional properties of your images, making them more compelling to the viewer. Line, the fundamental component of design, influences visual energy. A straight, horizontal line mimics the horizon, our primary source of orientation. It therefore creates a sense of calm and low energy. Vertical lines draw our eyes up along their length, giving pictures a sense of height and space, even when close cropping confines the image-area. The angles created by diagonal lines confront our sense of wellbeing and assuredness (the feelings supported by horizon lines) and, in so doing, create visual energy that brings life to otherwise static images.

Canada goose: I noticed the reflections of the trees on the water in this picture and decided to incorporate them in my picture design to add depth to the image.
Nikon D2H, 80–400mm VR lens set at 400mm, 1/125sec at f/11, ISO 200

Mountain lion: Diagonal lines, unlike straight, horizontal lines, add visual energy to a picture, making for a more dynamic composition.
Nikon D2H, 24–120mm VR lens set at 120mm, 1/200sec at f/5.6, ISO 400

Seeing light

Light is your most powerful compositional aid. Wildlife photographers rarely photograph during the middle of the day because the quality of light is generally poor. Early in the day and late in the afternoon are the most productive times for wildlife photography. At these times, light is shining from the side, creating shadows and contrast that accentuate form. Also, the light has to pass through more of the atmospheric layer, giving it a warm cast that causes wildlife pictures to sparkle.

Seasonal variations will also impact the quality of light. During summer, haze is more prevalent and the level of light often more intense. Shadows are harsh and levels of contrast become exaggerated. In winter, the sun rarely rises to its summer peak and beautiful sidelighting shines throughout the day. The reduced intensity causes shadows to soften, giving pictures a mellifluous presence.

Field Note

Early morning is my favourite time of day for wildlife photography. The quality of light is at its finest and the lack of dust in the air – which has greatly increased by the time sunset arrives – gives it a clarity found at no other time of the day.

Hooded vultures: I rose early to capture this image at first light.
Nikon D2H, 80–400mm VR lens set at 310mm, 1/320 sec at f/8, ISO 200

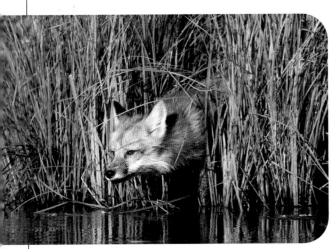

Red fox: Good light is as important to great wildlife images as it is to any other form of photography.
Nikon D2H, 80–400mm VR lens set at 400mm, 1/1250sec at f/5.6, ISO 200

Woodchuck: I thought I'd take this little chap's portrait before the setting sun sent him home to bed.
Nikon D2H, 24–120mm VR lens set at 102mm, 1/320sec at f/5.6, ISO 200

Expanding your repertoire

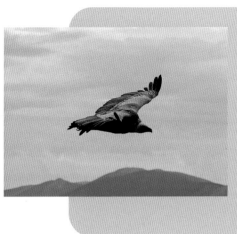

Once you have mastered the art of the animal portrait and are comfortable controlling the main camera settings to influence composition and visual tone, you will want to start expanding the types of wildlife pictures you take. Your primary aim should be to make more evocative and compelling shots, and in the following section I share some ideas for taking emotive wildlife images.

Taking great wildlife photographs requires the skillful application of a number of tasks, some of which, on the surface at least, have no direct link with photography. As well as knowing how to handle your photographic equipment and how to apply camera techniques in the field, a basic knowledge of your subject will go a long way to ensuring photographic success.

Photography is a means of communication – a medium for visualizing your emotional responses to the world around you. Because animals have characteristics, pure record shots and straight portraits do little to inspire us. Good wildlife images convey an insight into the subject, its mood and emotion, a sense of its environment or a behavioural trait. To develop imagery beyond straight animal portraits, these are the moments you should look for and capture with the camera.

Behaviour and interaction

No animal lives in complete isolation. Even solitary creatures, such as bears, have to mate and raise young. Other species, such as wolves, thrive in groups.

Equipment

Camera settings

When you are looking to take your wildlife photography to the next level, the aim is to shoot truly evocative images. To help you get the most out of your camera and to push your work beyond simple animal portraits, I recommend the following settings:

Mode	Setting
Shooting mode	Continuous
Focus mode	Continuous-servo AF with focus tracking
Metering mode	Multi-segment metering
Exposure mode	Aperture-priority AE
ISO rating	200

Photographing the interaction between animal groups can be a fascinating pastime and certainly makes for compelling pictures. Look out for courtship displays, a mother feeding her young, and young cubs playing together or mock fighting.

Whether in a group or in isolation, all animals display behaviour and photographing the right moment will give your pictures a stronger appeal. Including behavioural aspects in your pictures communicates information about your subject above and beyond species data.

Successfully capturing behavioural traits and animal interaction depends on knowing and understanding animal behaviour, being able to predict certain events and having the camera ready for when they occur. As well as picking up on some of the skills mentioned earlier in the book, you can do worse than spend time in the field simply observing a subject. After all, field craft is best practised in the field.

Baboon: Careful attention to composition can help accentuate behavioural traits. This young baboon seeks refuge from the pack in the embrace of its mother. ▶▶▶
Nikon D2H, 80–400mm VR lens set at 400mm, 1/8sec at f/8, ISO 400

◀◀◀ **Bee-eaters: Communal nesting sites make a great place to spend some time with your camera. Be patient and keep an eye open for interesting photo opportunities.**
Nikon D2H, 300mm lens with 2x teleconverter (600mm), 1/125sec at f/11, ISO 200

Field Note

When your aim is to capture interaction between subjects, always have the camera ready to shoot – the action can happen at any time, without warning. Fast shutter speeds and continuous shooting mode will help ensure you don't miss a thing.

African elephant and white
rhinoceros: Elephants are
one of the main causes of
white rhinoceros deaths
in Africa. Territorial
disputes are common,
as I witnessed here.
*Nikon D100, 80–400mm
VR lens set at 400mm,
1/1000sec at f/8,
ISO 200*

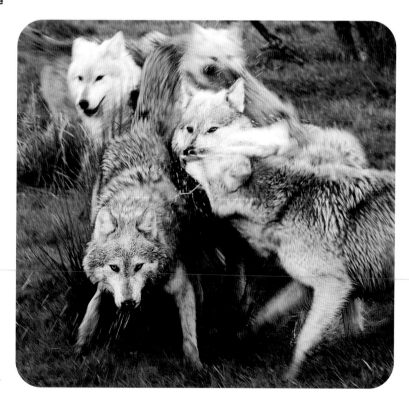

Grey wolves: Being pack
animals, wolves often
interact with each other,
particularly when food is
around. This sort of
knowledge will help you
to predict great wildlife
moments for your
camera to capture.
*Nikon D2H, 80–400mm
VR lens set at 80mm,
1/60sec at f/8, ISO 400*

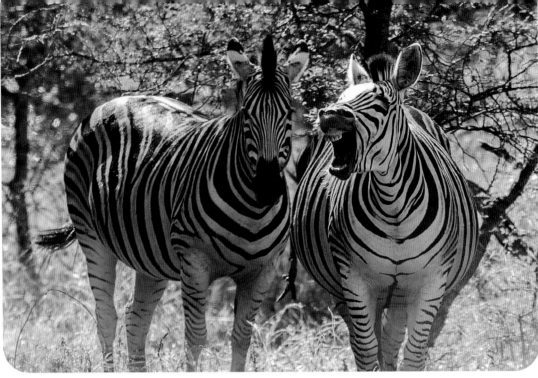

Plains (Burchell's) zebra: This picture never fails to elicit a reaction. It's simply a matter of timing – waiting for the right moment to press the shutter.
Nikon D2H, 300mm lens with 2x teleconverter (600mm), 1/160sec at f/8, ISO 200

Racoon: If you wait long enough, animals will invariably do the strangest things. This racoon lost its grip on the tree branch while changing its position.
Nikon D2H, 24–120mm VR lens set at 35mm, 1/1250sec at f/5.6, ISO 200

Emotion and humour

Outward displays of emotion are not unique to humans. Most animals display emotion in some form or another, whether it be the tender look of a mother with her newborn, the aggression shown between two territorial bears, or the sadness in a captive animal's eyes. Using a long telephoto lens to close in on and isolate facial expressions, as well as the eyes, can lead to some intriguing results.

Keep an eye open for everybody's favourite: the cute-and-cuddly shot. It's a

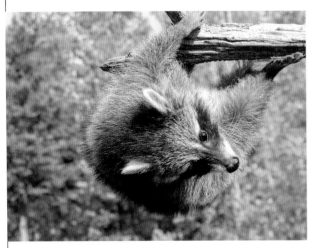

Indian elephants: Just practising!
Nikon D100, 80–400mm VR lens set at 400mm, 1/60sec at f/11, ISO 200

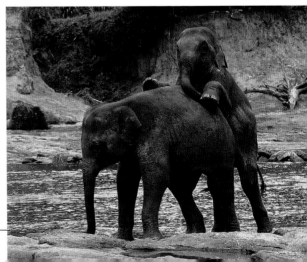

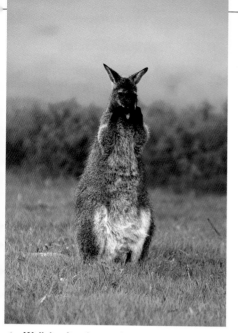

▲▲ **Wallaby: It takes patience to be rewarded with a snap like this, but spending time watching a subject rather than quickly moving on will often produce results.**
Nikon D100, 300mm lens, 1/60sec at f/5.6, ISO 200

▲▲ **Indian elephant: Cute and cuddly always sells, and there are few creatures in nature cuter than a baby elephant. This fellow was just a few days old and I had to be patient to get this shot as a forest of grey legs protected it from danger.**
Nikon D100, 300mm lens with 2x teleconverter (600mm), 1/60sec at f/8, ISO 200

commercial winner and definite inducer of the 'aaaahh' factor. This type of image is subject-dependent. After all, not all creatures are cute and cuddly. Anything young and with fur will appeal, as will the usual suspects like dolphins, baby elephants and orang-utans.

We all like to laugh and perhaps the most photographically successful emotion to portray is humour. A picture that captures a funny moment is bound to be a best seller – I once sold a book idea based on a single picture of a baby hippo. You have to be observant and use your imagination to catch these fleeting photo opportunities. Spending time with a group of animals, particularly those pre-disposed to humour, such as primates, usually leads to some interesting pictures. Keep the camera set-up ready for snapshot shooting to ensure you don't end up talking about the one that got away.

American Black bears: Bears learn much of the art of survival by practising on each other. These two yearlings took a brief respite from a playful wrestling match. ▶▶▶
Nikon D2H, 24–120mm VR lens set at 56mm, 1/640sec at f/8, ISO 200

Technique Tip

Snapshot shooting

It's always a good idea to carry your camera around with you. After all, you never know when a photo opportunity might arise. Keep a versatile lens on the camera, something like a 70–300mm zoom lens, and set all the camera settings to their most automatic positions. A good option is to set multi-segment metering in aperture-priority or SPORTS mode, AF to continuous servo, frame advance to continuous, plus all your normal shooting-parameter settings. Some D-SLRs also have a stand-by mode that will cut out any potential time lag caused by switching the camera on. Hopefully, when you spot an opportunity, it's a simple matter of grabbing the camera and pressing the shutter. There's little science involved, but you will at least get a shot.

Red fox: Many wildlife photo opportunities last barely moments and are often missed. Keep your camera ready in 'snapshot' mode to minimize the risk of letting an inspirational moment slip away.
Nikon D2H, 80–400mm VR lens set at 122mm, 1/500sec at f/5.6, ISO 200

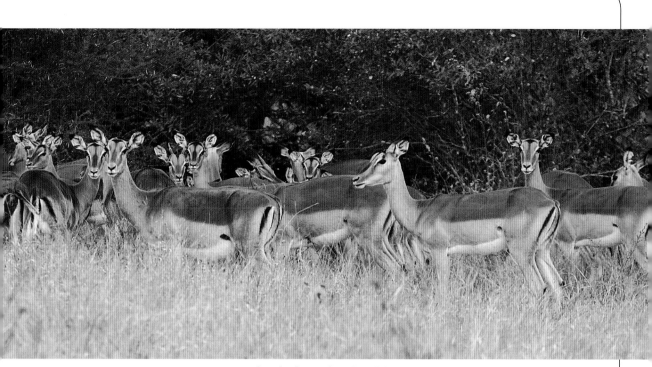

A sense of place

Animals do not exist in isolation from the rest of the environment, so include information about their habitat to give wildlife pictures a sense of place. Use a wideangle lens with a small aperture to accentuate the feeling of space and consider employing the rule of thirds (see page 98) when composing the picture. This may help to bring all the pictorial elements together. Also, check all areas of the viewfinder for any distracting objects or pictorial elements. You may find that using a polarizing filter will help to saturate colours in the background scenery and a graduated neutral-density filter (see page 122) will even out any tonal imbalance between bright skies and shaded foregrounds.

Impala: Remember that digital cropping can create new print formats. I purposefully shot this scene with a panoramic format in mind and the elongated dimensions provide a much better reflection of the lifestyle of these enigmatic characters.
Nikon D2H, 80–400mm VR lens set at 160mm, 1/125sec at f/5.6, ISO 200

Griffon vulture: Rather than simply another flying-bird shot, by including the mountains in the background of the image space I have created a sense of place.
Nikon D2H, 24–120mm VR lens set at 120mm, 1/400sec at f/5.6, ISO 320

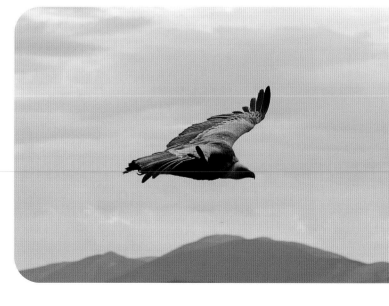

Brown bear (Ursus arctos)

Locations:

North and North-west North America, Northern Europe, and Asia.

Habitat:

Temperate and coniferous forest, including woodland; mountains; desert and semi-desert regions; open grasslands.

The Brown bear is the epitome of the wilderness. It is a powerful predator, whose relationship with man has, at best, been uncertain. Revered by Native American Indians but later slaughtered by man for their fur and for simple pleasure, numbers have dwindled to just a few thousand in their primary habitats. For the photographer, however, their antics and great presence make for wonderful photo opportunities.

Best location for photography: Brooks River falls in Katmai National Park, Alaska, USA. Every year, between 50 and 100 bears forget their preference for solitude and congregate along the Brooks River to catch the salmon run. Nowhere in the world are you likely to see more bears in one place and their habituation to humans has made them unwary of our presence.

▼ **During the summer salmon run, bears in Alaska's Katmai National Park are treated to a seafood feast.**
Nikon D100, 300mm lens, 1/125sec at f/5.6, ISO 200

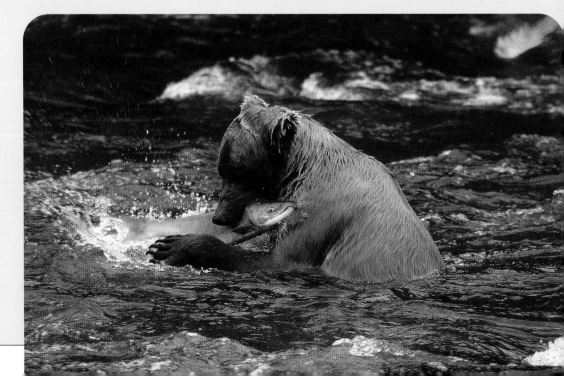

◄◄◄ **Salmon that make it past the bears along Katmai's Brooks River must face one final challenge – avoiding the hungry jaws of the dominant adult bears that line the length of Brooks River Falls.**
Nikon D100, 80–400mm VR lens set at 400mm, 1/100sec at f/5.6, ISO 200

Best time of year for photography: July, when the salmon are migrating back to their spawning grounds, is the ideal time for photography.

Shots to look out for: bears catching salmon along the top of Brooks River falls; bear interaction; yearlings and juveniles practising their fishing skills in the ruffles; mothers with spring cubs along the river bank.

Specialist equipment needed: a fast, medium-to-long telephoto lens (e.g. f/2.8 300–400mm) plus teleconverter.

▼▼ **Brooks River Falls in Alaska's Katmai National Park is the best location for Brown bear photography in the world. Be prepared, however, to share the shooting platforms with several other photographers!**
Nikon D2H, 800mm lens, 1/200sec at f/8, ISO 200

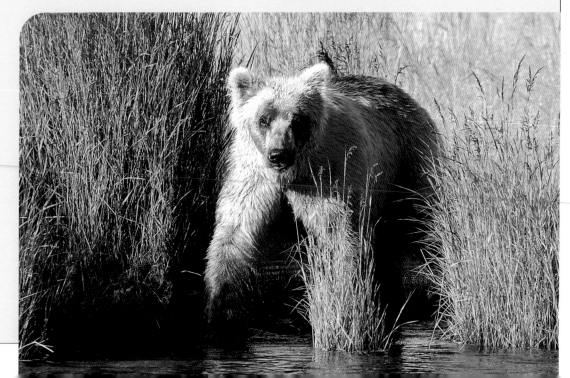

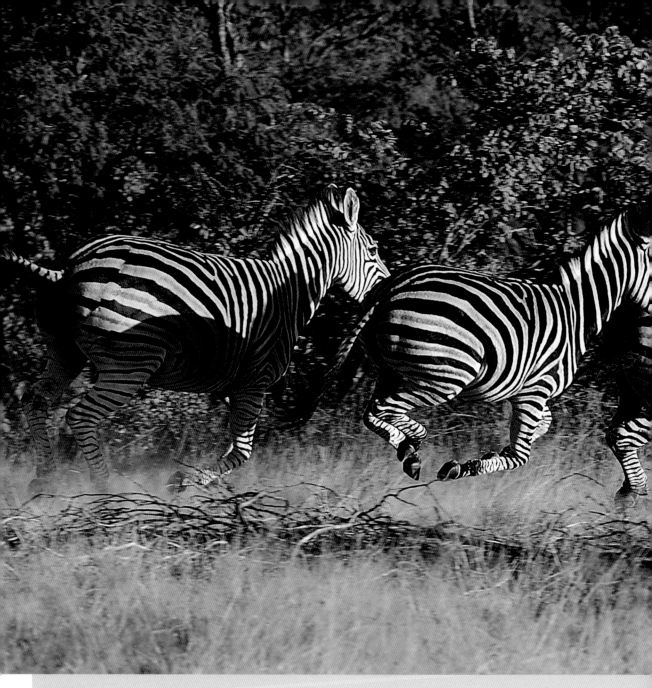

Advanced Techniques

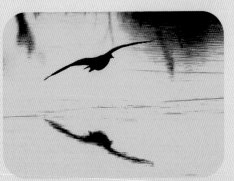

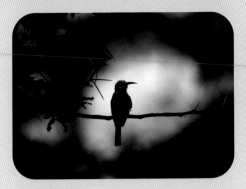

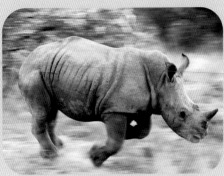

Specialist equipment

As you become more proficient in wildlife photography, and as you reach and surpass the limitations of consumer-grade equipment, you will undoubtedly think about upgrading to more specialist gear. The following section looks at some of the specialist equipment and the more advanced camera functions that are often used in wildlife photography.

▲▲▲ **Professional-specification D-SLRs offer a range of benefits, from better build quality to more sophisticated AF systems.**

Professional-specification cameras

As the saying goes, you get what you pay for, and this is certainly true of cameras. Professional-level digital cameras are built to a higher standard of quality, using stronger materials with hard-wearing outer layers. Joints and orifices are sealed against penetration by dust and moisture, making them more suitable for use in extreme environments. You will also find that the AF systems used in these cameras are faster and more accurate than those used in less sophisticated models, and burst rates are often much improved, with speeds beyond 8fps.

The other main distinction you will notice is resolution. While an entry-level camera might have a 6mp sensor, and mid-range cameras something like 8mp, professional-specification cameras offer double digits, with 12, 14 and 16mp sensors available.

The greater resolution provided by such cameras gives improved reproduction quality, making them desirable if you are considering selling your images to magazines or photo libraries. Also, while double-digit megapixel

size may be excessive for home printing, you may find that the additional features of professional-specification cameras make the investment worthwhile. Be warned, however: these cameras are not cheap, so you will be paying for the privilege.

Specialist lenses

Lenses are one of the most important components of a camera system. I'd rather have an expensive lens on a consumer-grade camera than vice versa. As your level of photography improves and you challenge yourself to take on more advanced techniques, the need for more advanced optics – fast maximum apertures, high-speed and/or silent AF – will become increasingly apparent.

Fast super-telephoto lenses

Fast super-telephoto lenses have a large maximum aperture, which makes them ideal for fast-action wildlife photography. The extra couple of stops you gain in light gathering can be transferred to shutter speed. This means, for example, that

when you were previously shooting at 1/500sec you can now increase shutter speed to 1/2000sec – a speed far more likely to freeze fast action.

These lenses are also more suited to use with a teleconverter. Fitting a 2x converter to a 400mm f/2.8 lens will give you an 800mm f/5.6 optic, which is still extremely fast for its focal length. The same teleconverter on a 100–400mm f/5.6 zoom lens will give you a maximum focal length of 800mm and a maximum aperture of f/11, which is hardly conducive to wildlife photography.

Specialist optics, such as this fast, super-telephoto anti-vibration lens can be found in the kit bags of many professional wildlife photographers.

Equipment

Advanced kit bag
To open up new possibilities in your photography, you will want to expand on the simple kit bag I outlined earlier (see page 91). The equipment below is just a suggestion and you will need to fine-tune it to suit your own needs, but this should give you a sound basis from which to work.

Camera body	Professional-specification digital SLR with continuous-servo AF, high-speed frame advance and large-capacity buffer
Lenses	Fast wideangle AF zoom (e.g. 17–35mm f/2.8) Fast telephoto AF zoom (e.g. 70–200mm f/2) Fast super-telephoto AF prime (e.g. 300mm f/2.8) with anti-vibration technology 1.4x and 2x teleconverter
Digital accessories	2 x 1gb memory cards Portable storage device
Other accessories	Carbon-fibre tripod with ball-and-socket or gimbal-type head Monopod Cable release Beanbag Powerful flash unit with off-camera bracket and cord Spare camera battery Infrared remote control

The disadvantages of these lenses are their size, weight and cost. Wide apertures require large front elements and lots of glass inside. You will find that size increases and weight more than doubles, which makes hand-holding close to impossible and a tripod or beanbag must be used to ensure a pin-sharp image. As for cost: as an example, expect to pay four times as much for a 300mm f/2.8 lens as you would for the one-stop slower 300mm f/4!

Lenses and perspective

When you switch between focal lengths, you change the way the camera (and ultimately the viewer) sees the subject. You also alter the relationship between pictorial elements. In effect, you are altering visual perspective.

In 35mm-format terms, a lens with a focal length of 50mm is said to be a 'standard' lens. This is because its angle of view is close to that of human vision.

Equipment

Digital-specific lenses

Digital photo-sensors gather light differently to film. Film can accurately record light falling on it from any angle, however acute it may be. A sensor, on the other hand, needs light to strike it at as close to 90 degrees as possible to record accurate detail. Some traditional lenses are manufactured with a slight curvature that increases towards the outer edges of the lens. This directs light away from the edges of the frame and can lead to blurred edges on digital images, especially those taken with full-frame sensors. (It is less of a problem with cropped sensors – because of their reduced angle of view they only use the flatter central portion of the lens.) Therefore, while lenses designed for film cameras will work efficiently with a digital camera, a lens designed specifically for the job will give optimum performance and produce better quality results.

Of the main manufacturers, Nikon and Olympus have led the way in digital-specific lens design. Others are now following suit, including Canon and Tamron. Currently, choice is limited; because the likelihood of image-quality degradation is greater at wide angles, you will find that more wideangle lenses are digitally integrated than lenses with longer focal lengths.

Because of the differences between how digital photo-sensors and film record light, many manufacturers now produce lenses specifically for the digital format. For optimum image quality, you may want to consider such lenses.

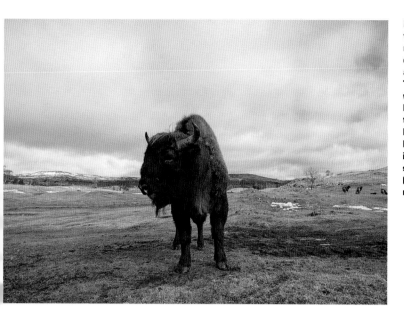

European bison: Compare the three images on this page and note how using lenses with different focal lengths has altered subject magnification. The middle image was taken with a standard lens (which has an equivalent field of view to that of human eyesight). Reducing focal length (left) has reduced the size of the image in the picture space; switching to a telephoto lens (bottom) has increased magnification even further.

If you increase focal length to 100mm, you are doubling the size of the subject in the frame compared to a 50mm lens. A 200mm focal length quadruples it, and so on.

Conversely, when you reduce focal length, the subject becomes increasingly small. So a 24mm wideangle lens will roughly halve image magnification, while a 12mm optic will reduce image size to around a quarter of that when taken with a 50mm lens.

What does this mean to the wildlife photographer? When photographing small animals or wildlife that is some way off, a telephoto lens will reduce the optical distance between the camera and the subject, increasing the size of the subject in the picture space to produce a frame-filling image.

As you reduce focal length, the optical distance of the subject increases and more of the area surrounding the subject is included in the frame, creating an image where visual strength is given to sense of place.

As well as altering the optical distance between the camera and the subject (by switching between focal lengths) you can increase or decrease the size of the subject by changing your physical distance from it – i.e. moving closer to increase subject size and further away to reduce it.

The effect, however, is very different from that achieved by altering optical distance, and depends upon the lens used. When you change your position and switch to a wideangle lens, spatial relationships will be stretched and the sense of space around a subject will be increased. On the other hand, steping back and using a telephoto lens compresses space, placing emphasis on the main subject.

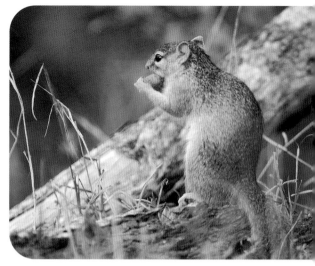

Ground squirrel: When photographing small creatures, or animals that are some way distant, a telephoto lens will reduce the optical distance between you and the subject to produce frame-filling images.
Nikon D100, 200mm lens, 1/60sec at f/8, ISO 200

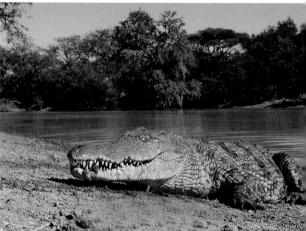

Crocodile: When you compare these two images, you will note that while the subject magnification in both is similar, the composition of the pictures is very different. This is because of the different focal lengths (102mm and 24mm) that were used.
Left: Nikon D2H, 24–120mm VR lens set at 102mm, 1/320sec at f/4.6, ISO 200. Above: Nikon D2H, 24–120mm VR lens set at 24mm, 1/500sec at f/3.6, ISO 200

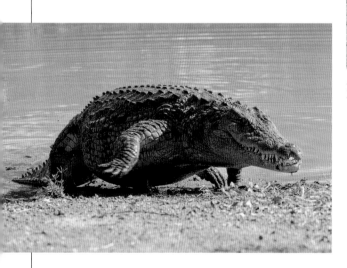

I rarely use filters for wildlife photography ▶▶▶ **but they can have their uses.**

Using filters

I rarely use filters when photographing wildlife and have even less need of them when using a digital camera. However, there are a few occasions when they will make a difference to your work.

Colour-correction filters
The role of the colour-correction (CC) filter – typically the 81 series of 'warm-up' filters and the 80 series of blue filters – has been largely negated by the WB control. Adjusting the kelvin value of the WB will produce the same effect as using a warm-up or blue filter, and applying a CC filter to the lens will affect the WB reading taken by the camera in the auto setting.

▼ **Lilac-breasted roller: A polarizing filter will**
▼ **help to saturate bold colours. I used one here to intensify the beautifully coloured feathers of this bird.**
Nikon D2H, 300mm lens with 2x teleconverter (600mm), 1/320sec at f/11, ISO 200

Polarizing filters
As well as helping to saturate colours, polarizing filters can be used to minimize surface reflections from water and glass, making them a potentially useful accessory. I use them sparingly as they reduce the level of light entering the lens by up to two stops and I can rarely afford the loss in shutter speed or aperture.

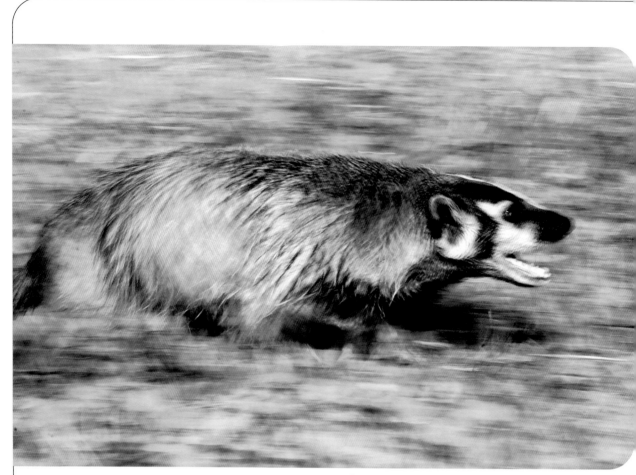

Neutral-density filters

Neutral-density filters reduce the level of light entering the lens and can be used to enable setting a slow shutter speed in bright conditions. One could be useful if I want to photograph motion blur, for example, but cannot manage a slow enough shutter speed given the level of light. They come in varying strengths from one to three stops (in half-stop increments) and can be used in combination.

Graduated neutral-density filters

These filters have the same effect as neutral-density filters but are graduated between clear (no effect on light levels) to dark (reduces light levels by the specified number of stops). These filters are typically used when including a large area of the surrounding scenery with a bright sky, as they will even the tones between a shaded foreground and bright background.

Badger: A neutral-density filter allowed me to set a slow shutter speed for this motion-blur image of a badger. Without it, the light would have been too bright for such a slow setting.
Nikon D2H, 24–120mm VR lens set at 120mm, 1/30sec at f/25, ISO 200

Ultraviolet (UV) filters

UV filters block ultraviolet light. However, UV light affects digital photo-sensors far less than film. They can be useful if photographing at very high altitude, but are mainly used to protect the front element of the lens from damage, which they will do without affecting the recorded colour of a scene.

Creative exposure techniques

So far, I have talked about exposure primarily in terms of a camera's multi-segment metering system and autoexposure functions. However, as you become more confident with your wildlife photography, you can get more creative with exposure by switching the metering mode to spot metering or by using the manual exposure setting.

Selective exposure

Multi-segment metering uses complex algorithms to determine exposure values by assessing light levels in several portions of the frame. Spot metering allows you to do the same thing, except manually. This gives you far greater control over the appearance of the final image.

For example, compare the two images of bee-eaters, shown here. The first image was taken using the matrix metering system on my Nikon camera. It is well exposed and is a nice record shot of the occasion. For the second image, I switched to spot-metering mode and metered from the bright area of sky in the background. The result is a far more artistic interpretation of the scene.

Bee-eaters: These two images were taken just a few seconds apart, and yet they convey a very different visual message. The first image (above) was taken with the camera set to multi-segment metering and is 'correctly' exposed. For the second image (left), I switched to spot metering and metered an area of bright sky behind the bird. By changing my exposure, I have drastically altered the style of photograph. *Above: Nikon D2H, 300mm lens with 2x teleconverter (600mm), 1/90sec at f/8, ISO 200. Left: Nikon D2H, 300mm lens with 2x teleconverter (600mm), 1/1000sec at f/8, ISO 200.*

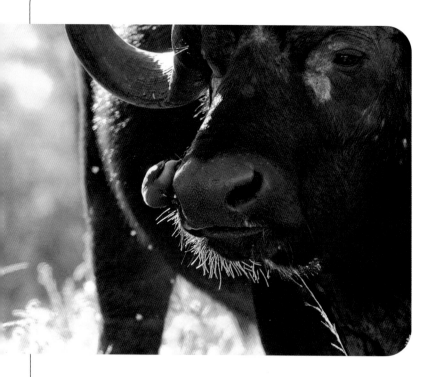

I used a similar technique for the picture of the buffalo. The first shot was taken using my Nikon's matrix metering system, which has produced what the technicians (and camera-club judges) will tell you is an accurate exposure. For the second shot, I switched over to spot metering and metered from the highlights on the buffalo's back. Again, the resulting image is far more abstract and artistic than the uninspiring original.

Buffalo: As with the Bee-eaters on the previous page, I used the same technique to capture this abstract image of a buffalo (below), metering from the highlights on the back of the animal. Compared to the standard exposure setting (left) the result is a far more artistic interpretation of the scene.
Left: Nikon D2H, 80–400mm VR lens set at 400mm, 1/125sec at f/8, ISO 200. Below: Nikon D2H, 80–400mm VR lens set at 400mm, 1/3000sec at f/8, ISO 200.

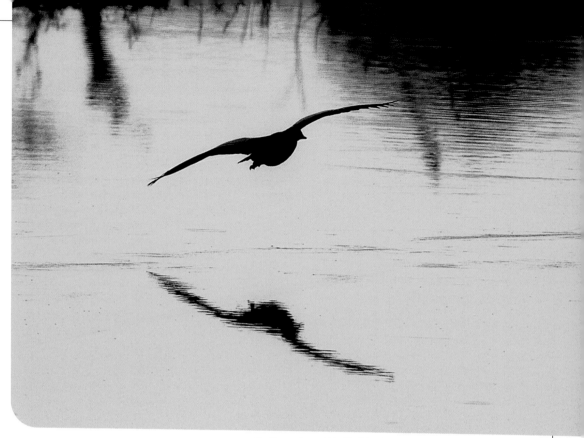

To capture this bird in silhouette I metered for the bright background and used **AE lock** on the camera to preserve the metered values before pressing the shutter.
Nikon D2H, 300mm lens with 2x teleconverter (600mm), 1/500sec at f/5.6, ISO 200

Complex lighting conditions

Taking control over exposure settings will further extend your creative abilities. However, knowing how to manage exposure will also enable you to more fully exploit complex lighting conditions, such as those detailed below.

Backlighting

When a subject is backlit, your AE system is liable to produce erratic and unpredictable results. In these conditions, I tend to switch to manual-metering mode and determine my own exposure settings to create the effect I want.

Silhouettes

Silhouettes make a particularly powerful graphic statement and can produce stunning wildlife images. You should expose for the highlights behind the subject, which means initially framing the image so that just the highlights can be seen in the viewfinder, and then setting the exposure.

With the exposure set (and locked using the AE lock button, if using AE), reframe the image to include the subject. If you are using manual metering, the exposure settings will remain unchanged even after you have recomposed the shot.

There are a couple of things to note when using this technique. First, because you are changing the composition of the image, remember to ensure that focus is locked onto the subject and not the background from which you took the meter reading. Second, in manual-metering mode, the analogue exposure display in the viewfinder may indicate an inaccurate exposure. You can ignore it because your meter reading has been taken from a different section of the scene to create the silhouette effect.

Rim lighting

To create a beautiful halo of golden light around a subject, first you will need to photograph at a time when the angle of the sun is low to the horizon. Again, set your metering mode to spot metering and the exposure mode to manual. This time, however, take a reading from the area of the animal facing the camera (the shadow side). Again, recompose the image if necessary, ensuring focus is locked onto the subject, and take the picture.

Wildlife photography in low light

During the early mornings (dawn and sunrise), evenings (sunset and dusk), and when photographing in dense woodland or forests, light levels will be low and you will need the extra light-gathering ability of a fast lens. This is where your 300mm f/2.8 and similar lenses really begin to earn their keep. The extra two stops that an f/2.8 lens affords over a slower f/5.6 optic can turn a very slow shutter speed of, say, 1/30sec into a more manageable 1/125sec.

Technique Tip

Adjusting tone

I've already discussed how the histogram can aid exposure calculations (see page 64). You can also use the histogram to determine the in-camera setting for TONE (contrast). The histogram is a visual reference to tonal range. If the bell of the graph is quite narrow, it is indicating a lack of contrast in the scene. To increase the level of contrast in the picture, increase the level of TONE compensation in the shooting menu. Similarly, if the contrast range is too great, you can reduce TONE compensation.

Plains (Burchell's) zebra: With the sun at a low angle and behind your subject, spot metering for the shadow areas will create a halo of golden light.
Nikon D2H, 300mm lens with 2x teleconverter (600mm), 1/160sec at f/10, ISO 200

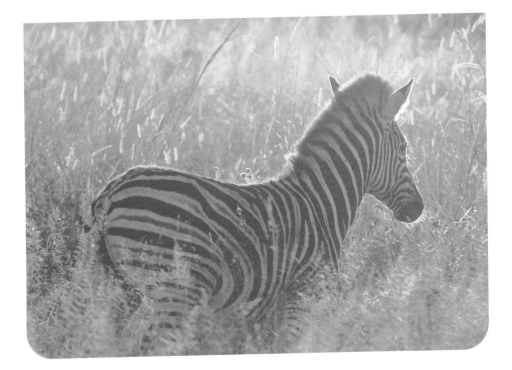

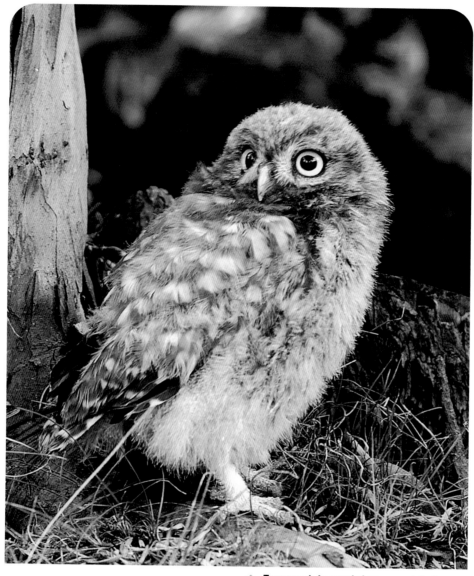

▲▲ **Tawny owl: In wooded areas and during times of low light, a fast lens will help maintain fast shutter speeds that ensure pin-sharp images.**
Nikon D2H, 24–120mm VR lens set at 120mm, 1/10sec at f/11, ISO 200

If light levels are still too low for an effective exposure, consider increasing the ISO rating. Beware of the effects of digital noise, however, which becomes more apparent at ISO ratings above 400. Flash is another alternative in low-light conditions, either as a fill-in (see page 129) to balance the existing ambient light or as the main source.

Digital cameras can be far more effective in low light than film cameras, but you still need to employ the same

level of care if you want to achieve results that excel. You will need to use a solid camera support, for example. A tripod is ideal but can be impractical if photographing from a vehicle or in any other confined space. The alternative is to use a beanbag (see page 40).

Flash photography

Wildlife photography usually occurs under daylight conditions, but there are times when a particular photograph requires the use of artificial light. Digital cameras operate with highly sophisticated flash units and the following chapter reviews the use of flash in wildlife photography, helping you to make the most of any challenges that nature throws at you.

◀◀◀ **When using flash, try to keep the flash unit off-camera by attaching it to a bracket. Off-camera flash will lessen the chances of red or green eye from ruining your pictures.**

Flash units are available as proprietary units or from independent manufacturers. Because of the level of technology now available in flash photography, compatibility is an important issue. Auto-electronic flash systems operate by passing information between the flash unit(s) and the camera. When choosing a particular model of unit, read the specifications carefully and consider reading the product reviews found on websites and in consumer photography magazines that offer impartial advice.

Power output

Power output, usually represented by the unit's guide number (GN), is the main, but not only, consideration. More powerful flash units will give you greater control over lighting and exposure. When comparing GNs between different units, be aware that the calculations used for marketing purposes are non-standardized. For example, while one manufacturer may quote a GN based on an ISO setting of 100, another may use 400 as the basis

for calculation. This will make comparing the two units a slightly more difficult task.

Fortunately, calculating flash exposures is now far less complex than it used to be, given the technology built into modern TTL flash systems. For both fill-in flash and when using flash as the primary light source, the combination of the processors in the flash unit and camera body should result in perfect exposures on the majority of occasions.

Field Note

You can adjust the power output of the flash from the camera's calculated output by setting flash exposure compensation. From experience, I have found that applying negative compensation (–) when my subject is close to the camera, and positive compensation (+) when it is more distant, helps to achieve a natural balance between light from the flash unit and ambient light.

Reducing red eye

Most D-SLRs have an accessory or 'hot' shoe to take the flash unit. However, having the unit directly above the camera along the sight line between subject and lens will often produce less than complimentary results. As with humans, many animals' eyes will reflect light directly back off the retina. This will cause the effect known as red eye, or a slight variation – green eye. Either way, it's unpleasant.

The solution is to position the flash unit off-camera on a bracket, and connect it to the camera's computers via a special electronic cord designed to work with your camera. Angled in and down on your subject, the lighting produced by this set-up will appear more pleasing to the eye, creating shadows that define form and removing the possibility of red or green eye. If this is not possible, red eye can be removed at a later stage using an application like Photoshop.

Fill-in flash

Fill-in flash is a particularly useful technique when photographing animals in direct sunlight. Hard (direct, point) lighting conditions will cause dark shadows to form, particularly under the eyes and around and under the nose of animals. These shadows can be unflattering and obtrusive in the picture composition. Using a burst of artificial light to lift shadow areas of a scene lit by natural light will ensure that tones are kept even and that a natural balance between highlight and shadow exists.

When photographing a side-lit subject, the shadow can often contrast starkly with the lit side. This often results in a compromise exposure, where you must choose between retaining detail in either

Technique Tip

Slow-sync flash

In low light conditions, using fill-in flash may result in underexposed backgrounds, rendering them very dark or even black. To avoid this scenario, if your camera or flash unit has a setting for slow-sync flash, set it to this mode. Slow-sync flash utilizes a slower shutter speed, which allows enough ambient illumination to light the scene, giving more natural results.

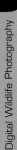

African Fish eagle: Flash can be used in order to help freeze the motion of fast-moving subjects.
Nikon D2H, 12–24mm lens set at 12mm, 1/250sec at f/7.1, ISO 200, Nikon SB-800 i-TTL flash

the shadow areas or the highlights, but not both. Turning the subject so that their back is to the sun won't solve the problem, since the face will still be in shadow and you'll be faced with exactly the same dilemma.

The answer, of course, is to use fill-in flash. Most modern flash units provide an automatic setting for calculating fill-in flash exposures. The principal technique positions the flash unit on the unlit side of the subject (using the off-camera set-up described on page 129). When the picture is taken, the flash unit adds a small burst of light into the shadow areas, lightening areas of detail and equalizing

the tonal balance. The real trick is to give just the right amount of light. Too little will be ineffectual, too much will overpower the ambient light and detract from your original composition. The effect you are looking for is one where the viewer is unaware that flash was used at all. (Note: the effects of flash vary from one type to another. It is therefore wise to refer to your unit's manual for full details.)

Action photography

Perhaps the ultimate challenge for a wildlife photographer is photographing animals in action. Good action photography combines all the skills of camera knowledge, composition, shooting techniques, approach and equipment choice – hopefully culminating in a powerful, compelling image.

Expect the unexpected

Action photography falls into two categories: predictable and unpredictable. When the action is predictable, you will need to set a fast shutter speed and use the camera panning technique (described on page 136) to follow the movement of the animal. I would advise setting the camera to continuous-shooting mode and fire off three or four frames at a time to ensure you get the animal in the frame and at the peak of the action. For the best results, predetermine the point of exposure so you can anticipate the shot with greater accuracy.

Plains (Burchell's) zebra: ▶▶▶
I fired off three shots when photographing this zebra in Kruger National Park. Although all three images were well exposed and in focus, only this one (the second of the three) caught the animal in mid-leap.
Nikon D2H, 300mm lens, 1/400sec at f/5.6, ISO 200

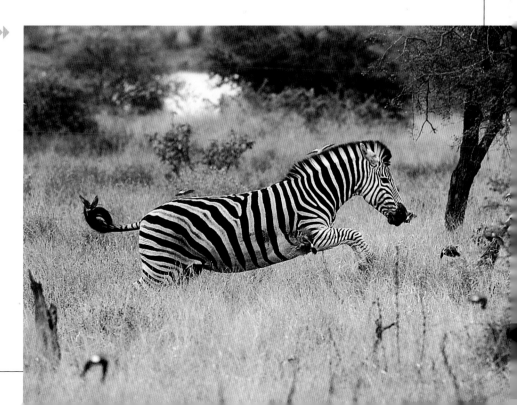

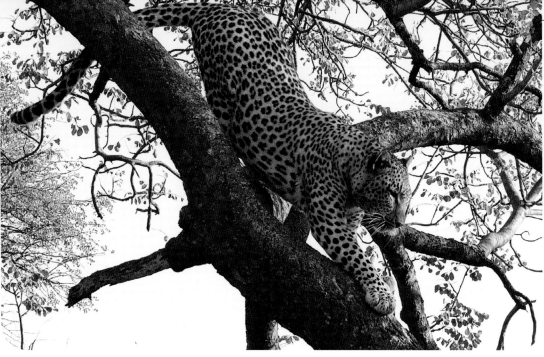

African leopard: I knew from experience that this leopard would makes its way down the tree branch and so could predict the action and have the camera ready and set for the shot.
Nikon D2H, 80–400mm VR lens set at 80mm, 1/250sec at f/11, ISO 200

Unpredictable action requires a slightly different approach. Speed is the key – fast shutter speeds (in excess of 1/500sec) and fast, accurate focusing are essential for freezing action and producing pin-sharp images. You will need to select your AF target sensor with care and then trust the camera to keep up with events as they play out in front of you. High-speed continuous-shooting mode will ensure that you capture particularly expressive moments, but be careful not to whizz your way through your memory capacity too quickly, otherwise you may find you're out of frames before the best of the action is over. Also, bear in mind the limitations imposed by your camera's burst rate and depth (see page 68 for tips on how this can be managed successfully).

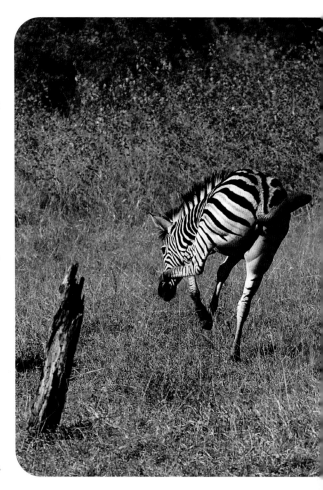

Plains (Burchell's) zebra: Unlike the leopard (above) this young zebra had me guessing all the way. I adjusted the camera settings continually to make sure I captured the action.
Nikon D2H, 80–400mm VR lens set at 250mm, 1/640sec at f/8, ISO 200

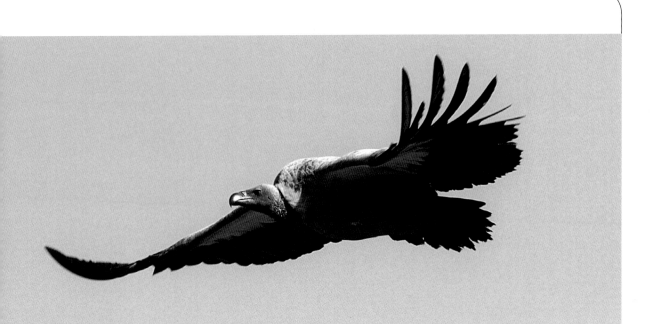

Hooded vulture: Getting the camera settings right will help you to photograph animal action, such as birds in flight, successfully. The box (right) gives my recommended settings for general action photography.
Nikon D2H, 80–400mm lens set at 210mm, 1/500sec at f/8, ISO 200

Equipment

Camera settings

When the action is unpredictable, the challenge increases. You will have little if any time to anticipate the shot and will need to concentrate on what you are seeing through the viewfinder to know when to press the shutter. This is when knowing how to operate your camera by instinct becomes most important. Having your camera set up correctly can help a great deal and means that you won't be fiddling with the controls just as that once-in-a-lifetime shot passes you by. When it comes to photographing animals in action, the following settings should give you a good starting point:

Mode	Setting
Shooting mode	Continuous
Focus mode	Continuous-servo AF with focus tracking
Metering mode	Multi-segment metering
Exposure mode	Shutter-priority AE
ISO rating	200–400

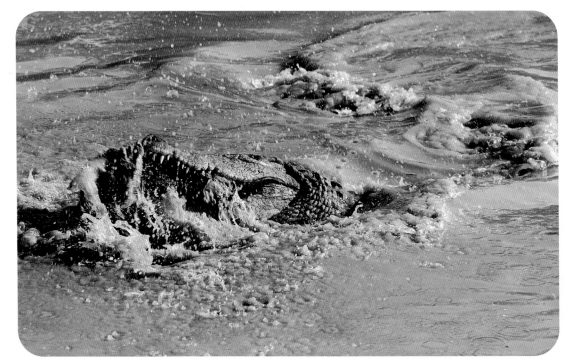

Crocodile: Capturing this sort of action is almost impossible using a tripod and I tend to prefer hand holding the camera. Whenever possible, I use anti-vibration lenses to reduce the likelihood of image blur caused by camera shake.
Nikon D2H, 24–120mm VR lens set at 120mm, 1/400sec at f/8, ISO 200

Camera handling

It is far easier to follow the action when hand holding the camera, so use a lightweight, physically small lens or anti-vibration technology. Alternatively, a monopod is a more flexible option than a tripod. If you have to use a tripod, choose one with a ball-and-socket head and keep the ball loose to allow free movement of the camera in all directions. For more serious applications you may want to invest in a gimbal-type tripod head. These are designed specifically for use with super-telephoto lenses and, although expensive, give perfect balance.

When framing the image in the picture space, give your subject some room to move within the frame. If you zoom in too tightly you are liable to chop off a part of the animal's anatomy (figuratively speaking) as it moves around the image space. Always consider where the animal will be when you take the picture, rather than where in the frame it is to begin with. A zoom lens will help you to adjust the framing as necessary.

Field Note

You will notice that it can be difficult to pinpoint a distant subject within the viewfinder when using lenses with very narrow angles of view, such as long telephoto lenses. The trick is to take note of any key environmental features around the subject while you are observing it with the naked eye. These will help you to orientate yourself when you switch to looking through the viewfinder.

A sense of motion

Because the shutter controls the length of time the sensor is exposed to light, it is the main controlling factor when creating images with motion blur. Generally speaking, if blur is your aim, you can ignore the age-old rule that insists a fast subject needs a fast shutter speed. For this technique, consider that rules are made to be broken. For most species of wildlife you will want to set a shutter speed somewhere in the region of 1/10 to 1/30sec. At these slower speeds, the shutter will remain open long enough to record slight movement without overdoing the effect.

Of course, 'slow' is a relative term when describing shutter speed. For example, when photographing exceptionally fast-moving subjects, like cheetahs, a shutter speed of around 1/250sec will still result in a level of motion blur. The same applies to some small mammals that can be deceptively quick over the ground. Recently, while photographing badgers, I found a shutter speed of 1/30sec far too slow and set the speed to 1/100sec to create a level of blur that was acceptable.

Field Note

Although shutter speed is the most important consideration when creating images with motion blur, lens aperture should not be ignored, as it will affect the quality of the background streaks. Use a small aperture to give sharper, better-defined edges to streaks, and a large aperture to make the edges softer.

African lion: There is a fine line between good and bad blur. Shutter speed is the key to creating images that portray motion without losing their purpose.
Nikon D2H, 24–120mm VR lens set at 38mm, 1/60sec at f/4.5, ISO 200

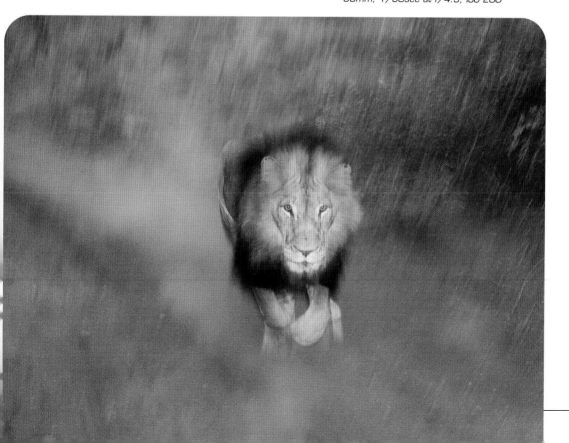

Panning the camera

To accentuate the appearance of motion, you can use the camera-panning technique. The trick is to follow the movement of the subject across the picture space from point A to point B. For best results, predetermine the point of image capture and press the shutter release just before the subject enters that point. Continue taking pictures until the subject has passed the predetermined point of exposure, taking care not to make any sudden jolts that could cause camera shake. Used with a faster shutter speed, this technique will freeze the motion of the animal while blurring the background. With a slower shutter speed, both the subject and the background will be blurred.

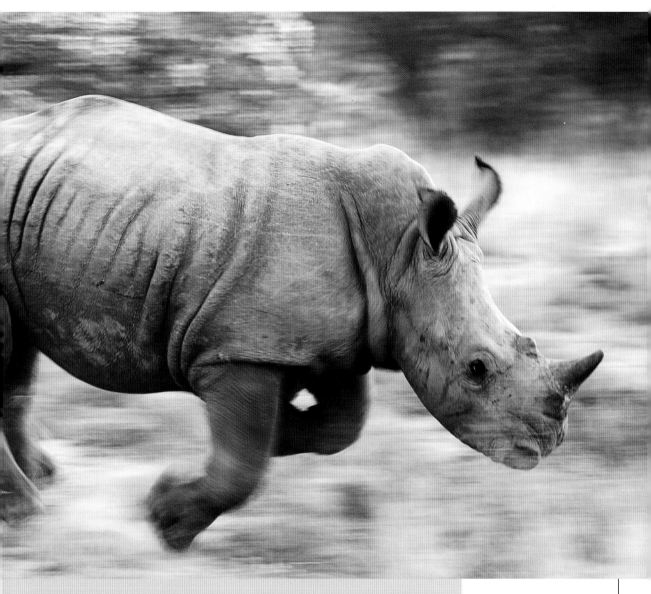

Grey wolf: I used a slow shutter speed while panning the camera to create this artistic image of a Grey wolf running through woodland in Minnesota. The slow shutter speed has created streaks from the light reflected by the foliage in the background.
Nikon D2H, 24–120mm VR lens set at 120mm, 1/20sec at f/8, ISO 200

White rhinoceros: For a sharper image, I used a faster shutter speed when photographing this young rhinoceros. Note how the change in shutter speed, from slow (wolf) to fast (rhino) has altered the visual presence of the photograph.
Nikon D2H, 24–120mm VR lens set at 120mm, 1/125sec at f/5.6, ISO 200

Lion (Panthera leo)

Locations:

Africa and Southern Asia.

Habitat:

Tropical forest; desert and semi-desert regions; grasslands and savannah.

Lions have always held a special place in the hearts of wildlife photographers. Although arguably not the most beautiful or, indeed, largest of the big cats, there is something about lions that makes our pulses race. Stare into the eyes of a wild male and you are quickly humbled by the power and potential ferocity of this king of the jungle.

Best location for photography: Many of the National Parks of Southern and Eastern Africa, including Kruger National Park (South Africa), the Masai Mara (Kenya) and the Serengeti (Tanzania).

Best time of year for photography: My preferred time of year for photographing lions is during the southern-hemisphere winter, particularly around June and July.

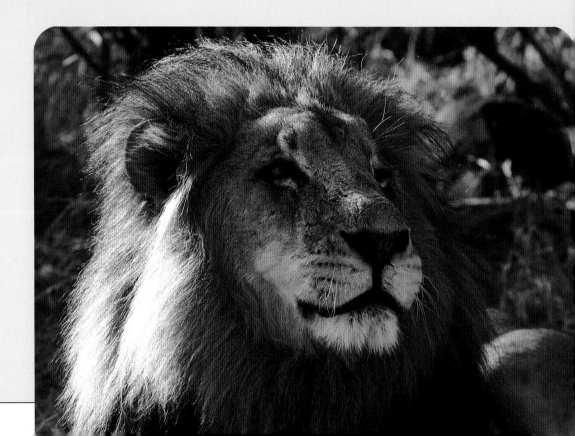

Despite the awesome power of the males, it is the lionesses that do most of the hunting in a lion pride. Here, a hungry female stalks her prey through the thick grasses of Africa's savannah.
Nikon D2H, 24–120mm VR lens set at 40mm, 1/640sec at f/8, ISO 200

Lack of rain means that grasses are low, making observation easier, and the lack of water makes known waterholes more productive for photographers.

Shots to look out for: feeding on a carcass; pursuing prey; interaction between members of a pride, particularly lionesses with cubs; clashes between two or more males.

Specialist equipment needed: a fast, long telephoto lens (e.g. 400–600mm) plus teleconverter.

My experiences with lions in Africa are testimony to their power and presence. The male is a proud and magnificent animal that deserves our respect as King of the savannah.
Nikon D2H, 80–400mm VR lens set at 180mm, 1/400sec at f/8, ISO 200

In From the Wild

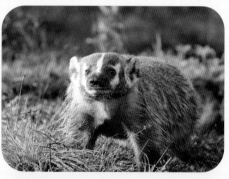

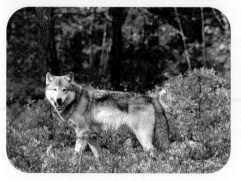

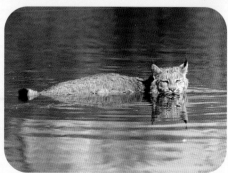

The digital darkroom

For those of us who remember fumbling in the dark to process and print our films, processing in the digital era is a welcome relief. Computer-based image processing has its critics, with questions raised about the ethics of image manipulation. In reality, most digital techniques have been taken straight from the traditional darkroom and few of the tools available in image-processing applications would come as much of a surprise to the great darkroom masters of the past.

The main change from the traditional 'wet' darkroom is the equipment (and, fortunately, the conditions in which that equipment is used). The enlarger has been replaced with a computer, keyboard and mouse, and you no longer have to work with the lights off! There is also a vacancy for a print technician: chemists need not apply.

The following paragraphs give a rundown of the key hardware and software components and some of the basic requirements of a digital darkroom. Budget will obviously be a factor in your choice of equipment, which should also be influenced by what you are hoping to achieve. If you have invested heavily in your camera gear in the hope of breaking into professional or semi-professional wildlife photography, this should be reflected in the quality of your digital darkroom. Of course, it isn't compulsory to have your own equipment. If you simply want a few prints to show to family and friends, many high-street stores now provide the means to get them.

Workstation

The starting point for an effective workstation is a PC or Apple Mac (it doesn't really matter which, they will both do an adequate job) with a fast processor; this means a minimum of 2ghz (PC) or G4 (Mac). You will also require a large-capacity memory (512mb or more) and hard drive (20gb or more). Of these, memory is the most important facet – the greater the RAM capacity, the faster the processing time.

Monitor

Most workstations are sold with a basic monitor, but these are often of relatively low quality and not ideal for photo processing. Monitor-type is another subject that fuels internet forum debates and, as usual, there are arguments for and against all options: aperture-grill vs. shadow mask, CRT vs. flat screen, black casing or white... no, just kidding! Whatever you read – and there's much to read on the subject – most professionals

I know use a LaCie ElectronBlue monitor, which is an aperture-grill, CRT monitor. When considering monitor size think in terms of a workspace – i.e. how much screen space you will need to show the image along with the various tool bars and dialogue boxes. A large screen is usually preferable (19–22in), but also consider a two-screen set-up, where one screen is used for displaying the image and a second screen shows the working tools.

External hard disk drive (HDD)

A large-capacity (100gb or more) external HDD is ideal for archiving digital files. By keeping the main storage drive external, you gain greater flexibility and added security. For example, if your computer fails you can simply unplug the external drive and plug it into a new machine without the need for complicated transfer processes. It also makes accessing your image library

from a remote workstation easier if you have no network capability, which is likely to be the case. The drive should be connected via a USB 2.0 or FireWire cable. Avoid using a USB-1-type-only drive or USB-1 connection, as the read/write times will be significantly slower.

DVD/CD-RW drive

These devices can be internal or external and many new computers now have them as standard. They can be used to compile image discs to send to clients or friends, as well as allowing you to back up the main external HDD. CDs typically hold up to 700mb, while DVDs are available with a capacity of up to around 8gb. This means that when storing a large number of images on disk, a single DVD will hold the equivalent of 11 CDs! Check that the drive can record (write) to disc as well as read them.

An external DVD drive is useful for archiving your digital images, or for backing up images as protection against accidental loss.

A suitable monitor is essential for effective image processing out of the camera.

Printer

To get prints of reasonable quality, you will need a colour inkjet printer. The three main contenders are Epson, Canon and Hewlett Packard, and each produce a range of printers that return excellent results for home printing needs. Your choice will be influenced by the size of output and typically you'll want to consider A4 (around 11x8in) or A3 (16x11in), although larger A2 (22x16in) printers for the desktop are available. Resolution as well as the number of ink colours used will affect print quality. Very basic printers use two cartridges, one for colour and one for black. This is fine, except that printers use up colours in different quantities and you may have to replace a whole colour cartridge even though only one colour has been fully consumed. More advanced printers use individual cartridges for different colours and tones. This not only produces better results, but is also less expensive to run in the long term.

Technique Tip

Colour management

Colour management is an important facet of digital photography. Simply put, cameras, monitors and printers all see colours differently. As a result, the image file produced by your digital camera differs from the image displayed on the computer monitor, and that, in turn, is different from the print that comes off your printer. This is partially caused by varying colour systems, but is also because cameras and monitors use different instructions to produce colour than printers – digital cameras and monitors use combinations of red, green and blue (RGB) while printers use cyan, magenta, yellow and black (CMYK). For critical applications, and particularly if you have in mind selling your images to publishers, you will need to calibrate your computer monitor and printer so that the colours produced are consistent. Calibration can be done via electronic tools in your computer, but is best managed using a hardware tool available from photographic and computer retailers.

For photo-quality printing, a modern desktop printer will produce great results up to A4 size (left) or larger.

▶▶▶

Technique Tip

Transferring images to your computer

Unless you transfer images to a laptop in the field, once back at home you will need to download images from the camera or portable storage device to your computer. Once downloaded, you can view them and apply any additional processing before printing or forwarding them on to friends and family via the internet or email. Here is a rundown of the main transfer methods:

Method	Description
Camera to computer	You can connect your camera directly to the computer via a USB cable. Once the computer has recognized your camera, you can transfer the files from the memory card onto your computer hard drive. I recommend using an AC adaptor when transferring images from the camera so that it doesn't shut down unexpectedly.
Memory card to computer	To save your camera's battery power and limit wear on its components, you can use a card reader. These small devices attach to the computer via USB. Once the card is inserted, files can be downloaded straight to the hard drive. These devices aren't essential, but can be more convenient than connecting your camera to the workstation. Some computers are now being sold with built-in card readers.
CD to computer	If you have saved your digital files to a CD using a portable CD writer, simply insert the disc into your CD drive on the computer and drag and drop the files into an appropriate folder on your hard disk drive.
Portable HDD to computer	Connect the portable HDD to the computer using an appropriate cable and, once the computer has recognized the drive, transfer the files to a relevant folder on your computer's hard disk drive.

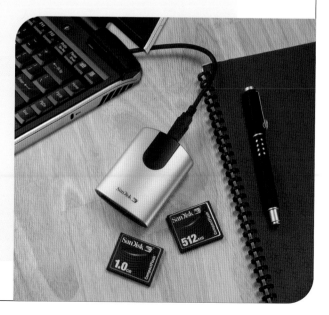

◄◄◄ **Card readers are a quick and convenient way of transferring your digital files from a memory card to a computer or laptop.**

Toolbox

Processing software like Adobe Photoshop contains a number of 'tools' that can be used to view and edit an image, many of which are based on traditional darkroom techniques. The diagram below outlines what I believe are some of the more useful options – tools that will enhance an image so that it accurately reflects your experiences, rather than those that can be used to create something entirely new. Some basic tips on usage can be found in the next section, which deals with simple image processing.

1 Lasso tool
Can be used to select a specific part (or parts) of an image. Any processes carried out, such as changes to the colour balance, can be isolated to this selection, or the area outside it. The magnetic lasso tool 'snaps' to the edges of defined areas, making it useful for quickly selecting objects set against high-contrast backgrounds.

3 Rubber stamp tool
Also known as the 'clone' tool. Samples an area of an image, which can then be applied over unwanted details, such as dust marks.

5 Zoom tool
Can be used to magnify an image up to 1600%, which is particularly helpful when checking or working on very small details. (Note: The size at which an image is viewed is based on monitor and image resolution, not on the actual image dimensions.)

2 Crop tool
Can be used to cut pixels from an image, simply by dragging the cursor over the area you want to keep. Useful for changing composition, cropping out unwanted details or emphasizing the main subject.

4 Toning tools
Can be used to lighten (dodge) or darken (burn) areas of an image. Based on traditional photographic techniques for adjusting exposure in specific areas of a print.

Processing software

Adobe Photoshop is the industry standard. Photoshop CS has the advantage that it can read RAW files, negating the need for proprietary software applications when accessing these file types (although plug-in updates may be necessary). Professional image-editing software like this can be expensive, so casual enthusiasts may prefer one of the versions aimed at home users, such as Photoshop Elements. A further alternative in the lower price bracket is JASC Paint Shop Pro.

Interpolation software

Interpolation (see page 162) can be done in Photoshop, but to re-size digital files to a professional standard, I and many other pros recommend a software application called Genuine Fractals. This uses advanced and sophisticated algorithms to manage the interpolation process and produce superior results.

Cataloguing software

Once you have several thousand images on file, you will want an easy method for locating individual images quickly. I have found that Extensis Portfolio provides a powerful and flexible search engine, with no limit to the number of images that can be catalogued. (For more on cataloguing, see page 165.)

Simple image processing

The following section outlines some basic image-processing techniques that will help you to enhance your digital images. They are simple techniques, honed in the 'wet' darkrooms of old, that can be mastered quickly and easily. The more creative techniques I'll leave to someone else!

I believe that there is a line to be drawn between image processing and image manipulation. Enhancing an image so that it more closely represents the scene as you saw it is one thing, and has been a part of photography since it was invented. Image manipulation – i.e. the act of manufacturing an image and then passing it off as something it is not – is something else entirely. Because of this, the techniques I have described here are specific to overcoming the limitations of the photographic process and digital photo-sensors.

Technique Tip

16-bit processing

If you have saved your digital images as RAW files, you will need to open them in the manufacturer's proprietary software before saving them as a TIFF or JPEG file. Alternatively, some generic software programs, such as Adobe Photoshop CS, enable RAW translation. RAW and TIFF files can be processed in 16-bit mode (as opposed to 8 bit). This makes image processing more accurate due to the increased number of brightness levels that are present.

Technique Tip

Editing JPEGs

When you save a file as a JPEG, it is processed using loss compression (see page 26). Every time you re-save a JPEG file as a JPEG, more original data is discarded. In order to maintain image quality, it is a good idea to save a file as a JPEG once only. If you start out with a JPEG file, save a copy as a TIFF file and use this for any in-computer processing. Once you have completely finished your work, re-save it as a JPEG at the end of the process.

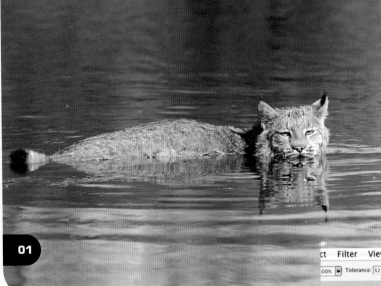

01

Increasing tonal range

01 For an image to stand out, it should have a full range of tones, from black through to white.

02 Open an image in Photoshop and review its histogram (WINDOW>HISTOGRAM).

03 In an ideal world, the chart would show a curve starting at the left-hand point and finishing on the right. In reality, it will be somewhere in between. (For an explanation of reading and understanding histograms, refer to page 64.)

04 Close the histogram and open the LEVELS dialogue box (IMAGE>ADJUSTMENTS>LEVELS).

05 You will see a new histogram, with small arrows marked underneath on the left, right and centre of a bar that looks like a greyscale. What you are

02

03

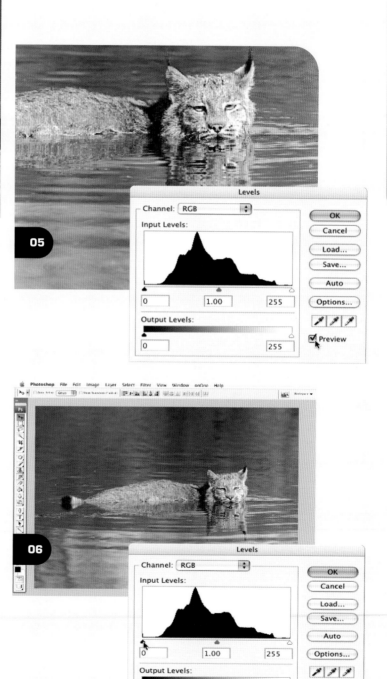

about to do is re-map the pixels so that the darkest area of the image becomes black and the brightest area of the image becomes white. This will increase the tonal range and, subsequently, contrast levels.

06 Make sure that the PREVIEW box is checked. Click the cursor on the left-hand (black) arrow and drag it to the point where the chart begins to rise. You will notice that the image darkens. The further you move it, the darker it will get.

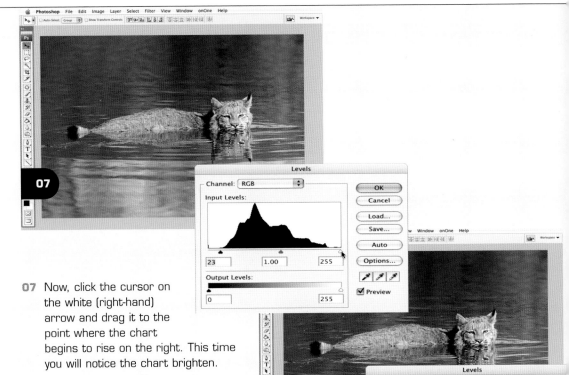

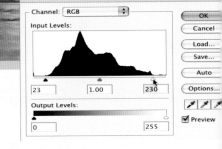

07 Now, click the cursor on the white (right-hand) arrow and drag it to the point where the chart begins to rise on the right. This time you will notice the chart brighten.

08 The centre arrow represents middle tone and can be adjusted if required, although I rarely find this necessary. Try experimenting a little by dragging it from left to right and notice the effect it has on your image. (The main purpose of the mid-tone arrow is to lighten or darken the overall image without significantly altering the shadows and highlights.)

09 The result of this re-mapping process is an increase in the level of contrast created by a full tonal range. Compare the two results and decide which you prefer.

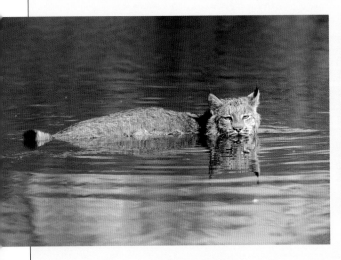

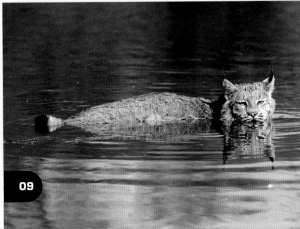

Equipment

Colour diagram

Colour has three basic attributes – hue, saturation and brightness – and the diagram below shows the relationship between these attributes. The vertical axis depicts lightness with white at the top and black at the bottom extreme. In between are the varying shades of grey that form the grey scale. The horizontal axis indicates the level of saturation. In the centre, colours are completely desaturated, becoming increasingly strong towards the rim where they are most pure. The rim edge illustrates hue, and shows how you can change the base shade of a colour by moving away from the starting point, altering the dominant wavelength of a colour.

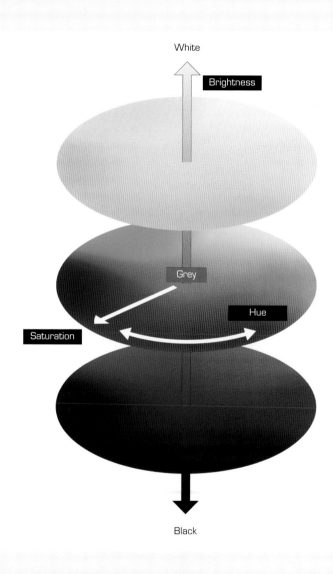

White

Brightness

Grey

Hue

Saturation

Black

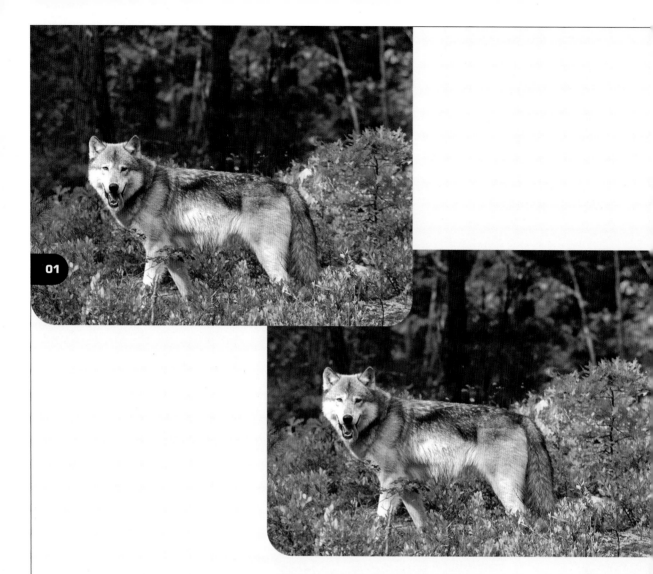

Increasing (and decreasing) saturation

01 When a landscape photographer wants to saturate the colours within a scene using film, he or she switches to using Fuji Velvia. You can achieve a similar result in the digital darkroom by increasing the level of saturation.

02 Open the saturation dialogue box (IMAGE>ADJUSTMENTS> HUE/SATURATION).

03 Click the cursor on the arrow on the middle bar and drag it to the right to increase saturation.

04 Notice how the intensity of the colours increases. A sufficient level is typically somewhere between +5 and +25. Above this level and you are beginning to overdo things a little. If the colours are too intense to start with you can tone them down by decreasing saturation. Take saturation right down and the image will become black & white.

Field Note

If your image has an apparent colour cast, you can adjust saturation levels for individual colour channels. For example, this image has a distinct blue colour cast, which gives it an unnaturally cool appearance. To reduce the blue tone, I have selected the blue channel (IMAGE> ADJUSTMENTS>HUE/SATURATION> EDIT>COLOUR CHANNEL) and reduced the saturation right down to zero. Compare the processed image with the original to see the effects.

05 To reduce the colour cast apparent in this image, specific colours are selected from the colour channel drop-down list and further fine adjustments are then made.

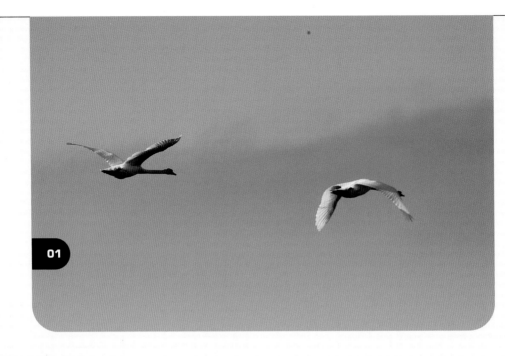

01

02

03

Removing dust residue

01 The unsightly marks left behind by dust and dirt residue on the photo-sensor can be removed using the CLONE tool in Photoshop.

02 Select the CLONE icon from the toolbar.

Equipment

NR software

Noise is a common problem in digital photography, as I have described earlier in the book. Some digital cameras have a Noise Reduction (NR) setting, accessible via the menu, to reduce the level of visible noise. Another option is to use independent software to do the same thing. Many professional photographers use a Photoshop plug-in application called Dfine by Nik Multimedia. The advantage of this application over the filters and actions built into Photoshop, for example, is that it assesses noise in relation to image detail and the consequences of noise reduction rather than applying a blanket approach.

Window Help

Window Help

igned | Sample: [Current Layer ↕] ⬚

04

05

⊕

03 Choose a brush size and style from the drop-down menu. For areas of single tone, a hard-edged brush will give the best results, while a soft-edged brush is preferable when cloning areas that contain a lot of detail.

04 Enlarge the image so that the area to be cloned can be seen easily on the screen. For very accurate and detailed cloning, increase the size of the image until you can see individual pixels.

05 To define the area to clone from, position the cursor in a clean area adjacent to the dust mark, then press ALT and click the mouse simultaneously.

Window Help

ed | Sample: [Current Layer ↕]

06

06 Next, position the cursor over the dirty area of the image and click the mouse again. The computer will replace the original pixels with pixels taken from the clean area of the image you selected previously.

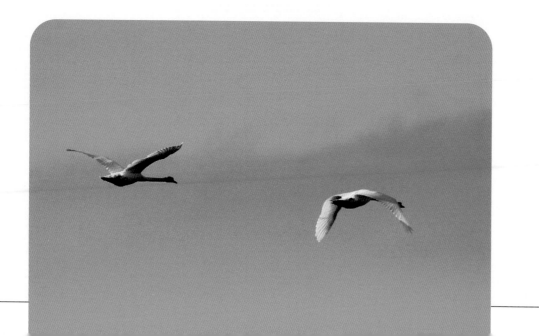

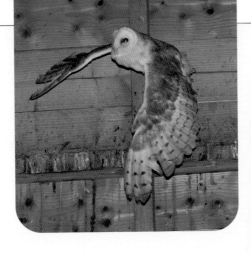

Overcoming red-eye

Red-eye is a common problem when photographing wildlife using flash front-on to the subject. You can use Photoshop to remove the red colouring from the eye following these simple steps.

01 Using the magnification tool, enlarge the affected eye(s) to a point at which you can identify individual pixels.

02 Select the LASSO tool from the toolbar and draw around the affected area of the eye(s).

01

02

03 To avoid a harsh, obvious outline, go to SELECT>MODIFY>EXPAND and choose a value of 1 pixel.

04 Then choose SELECT>MODIFY> FEATHER and set a value between 1 and 3 pixels.

05 To remove the red colouring, you are going to de-saturate the colour from the selected area, so choose IMAGE>ADJUSTMENTS>HUE/ SATURATION from the toolbar.

06 Then adjust SATURATION towards –100 until you get the desired result.

07 You will notice the red colouring turn grey. Click on OK and save the image.

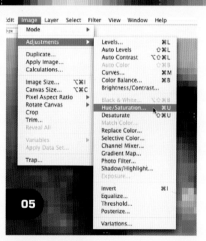

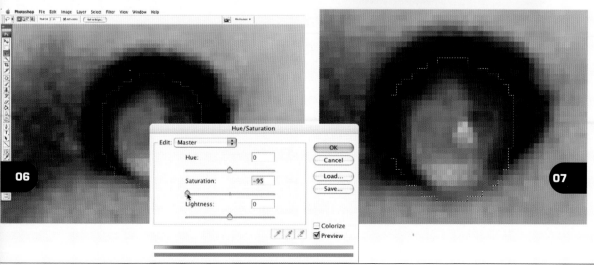

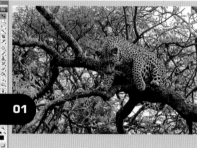

01

Cropping

01 To crop an image, start by selecting the CROP tool.

02 Hold down the mouse button and drag the cursor to enclose the area of the picture you want to keep. When you have finished, you will notice that the area outside the dotted boundary lines darkens.

03 Once you have selected the main area to crop, adjust the parameters of the crop to the precise size using the top, bottom and side pointers.

04 When you are happy with the new composition, action the crop by selecting [IMAGE>CROP] from the tool bar, or pressing the OK arrow to the right of the toolbar.

02

Field Note

Cropping an image deletes pixels. If you crop too much, you may reduce the size of the image to a level at which print quality is affected. To avoid this problem, increase the size of the image before cropping to make up for the loss of pixels.

03

Photoshop File Edit Image Layer Select Filter View Window onOne Help

Cropped Area: ⦿ Delete ◯ Hide ☑ Shield Color: ▇ Opacity: 75% ▸ ☐ Perspective ⊘ ✓ ◻ Workspace ▼

04

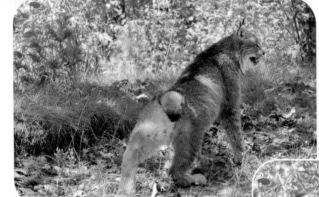

Image sharpening

01 The purpose of sharpening (also referred to as UNSHARP MASK or USM) is to restore edge definition within a scene where it has been lost in image capture. The principle is to exaggerate the contrast between the two sides of an edge.

02 You can control the parameters of USM by adjusting the three sliders in the dialogue box. One way of defining an edge is to increase the level of contrast. You can tell Photoshop the level of contrast to apply in USM by using the AMOUNT slider. By moving it further to the right, the dark areas become darker and the light areas become lighter.

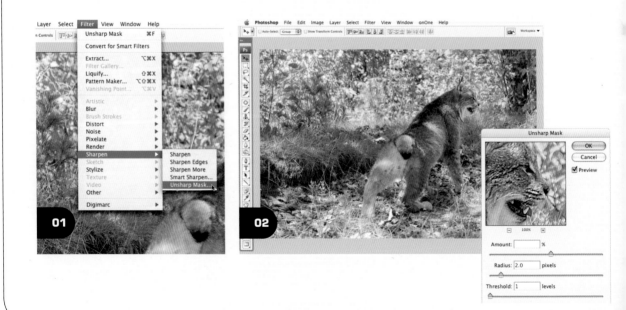

03 The RADIUS slider determines the number of pixels surrounding the edge pixels that are affected by the sharpening. For high-resolution images, a RADIUS of between 1 and 2 is recommended.

04 The THRESHOLD slider determines how different the sharpened pixels must be from the surrounding area before they are considered edge pixels and sharpened by the filter.

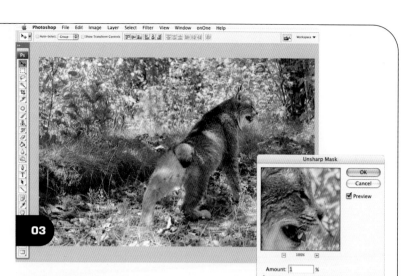

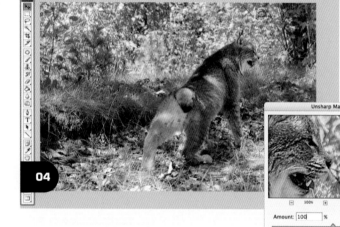

Equipment

USM settings

The best way to learn about the effects of USM is to experiment. Open a picture in Photoshop and apply different levels of AMOUNT, RADIUS and THRESHOLD with the PREVIEW box checked, then examine the results. As a guide, typical settings for standard USM applications are:

AMOUNT	80–100%
RADIUS	1 or 2
THRESHOLD	0 or 1

Field Note

Sharpening should be the very last thing you do in image processing. To retain image quality, run all other processing applications first, including re-sizing. If you are thinking of selling your images, most photo libraries request that images are submitted unsharpened. This is because they may have to re-size an image for their clients and USM can cause quality issues when magnified.

Digital Wildlife Photography

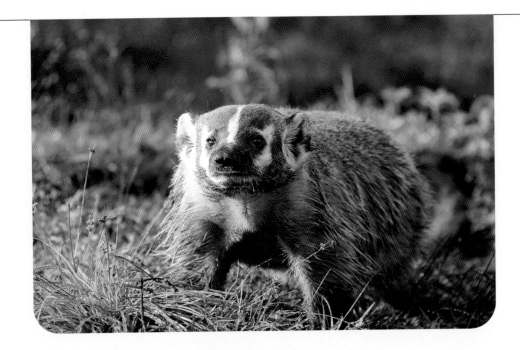

Re-sizing (interpolation)

To achieve quality prints above a certain size, you may need to re-size the original digital file – i.e. increase the resolution or number of pixels. The problem with doing this is how to avoid the loss of quality that often results in blurry or pixilated images.

There are two methods for increasing the size of an image: re-sizing and re-sampling. Re-sizing an image will increase the print size without altering the

◀◀◀

Image re-sizing can be achieved using software like Photoshop simply by increasing the number of pixels an image contains. However, a substantial increase may have a negative effect on image quality.

◀◀◀

An alternative solution is to use an interpolation program like Genuine Fractals. In this case, the first step is to re-save your image as a Genuine Fractals file.

total pixel dimensions. As resolution is decreased the print size gets larger, and vice versa. This results in no actual loss in quality but print resolution (ppi) is compromised. An alternative method is to re-sample, or interpolate, the image using computer algorithms. This process involves increasing the number of pixels in the image by adding new ones based on the value of existing pixels. Using this method, print resolution can be maintained but image quality can be compromised because the computer is effectively guessing the value of the new pixels.

Most interpolation software packages provide different interpolation methods. The most common are bicubic, bilinear and nearest neighbour. Bicubic is the slowest of the three processes but produces the best results. Bilinear is quicker but less effective. Nearest neighbour is best avoided as the results are often very poor – it simply takes the value of the adjacent pixel and mirrors it.

The Genuine Fractals file extension is .stn, as can be seen here. ▶▶▶

Save as .STN

Please choose the compression method you would like Genuine Fractals to use to save this file.

Lossless compression will create a file that is a digitally exact replica of the original file. Lossless compression typically reduces the file size at a rate of 2:1.

Standard compression will create an even smaller file, but will discard some of the image data that typically is imperceptible to the human eye. This method of compression typically reduces the file size at a rate of 5:1.

Cancel Standard Compression Lossless Compression

◄◄◄
You will be asked whether you want to save the file with or without compression. My advice is to save it as a 'lossless' file.

Once the file has been opened, you can select whether you want to work in inches or centimetres. ▶▶▶

Genuine Fractals Express
Pixel Dimensions
File Size: 15.34 MB Reset
Width: 2464 pixels ▼
Height: 1632 pixels ▼
Document Size
Reset
Width: 8.21 inches ▼
Height: 5.44 inches ▼
Resolution: 300 pixels/Inch ▼
☑ Constrain Proportions
Cancel Apply

Various re-sizing options are available. Here, the print size is being increased.

Genuine Fractals Express
Pixel Dimensions
File Size: 15.34 MB Reset
Width: 2464 pixels ▼
Height: 1632 pixels ▼
Document Size
Reset
Width: 8.21 inches ▼
Height: 11.425 inches ▼
Resolution: 300 pixels/Inch ▼
☑ Constrain Proportions
Cancel Apply

Field Note

Some people suggest that you get a better quality result when re-sizing in incremental steps rather than in one single step. In fact, the opposite is true. Incremental re-sizing in up to ten steps shows no discernible difference. Beyond ten steps image quality is degraded, becoming increasingly poor as more steps are used.

◀◀◀

Cataloguing software allows you to view images as thumbnails, making it easy to find and select a particular shot.

A good program will allow you to attach keywords to an image. This will enable you to search through your archive with great ease, finding a shot (or shots) of any particular type or subject.

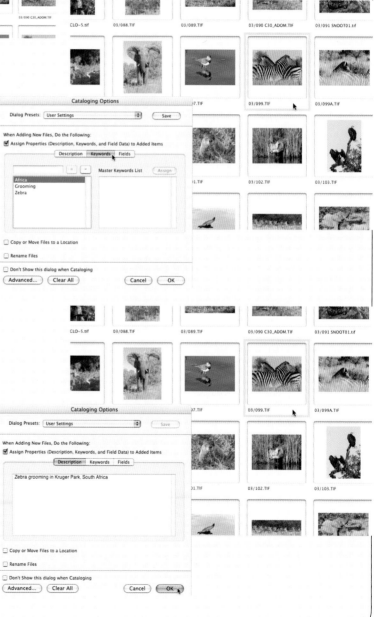

Cataloguing

When you have only a few images, it is a simple task to locate them on the computer, particularly if you have saved them in an identifiable folder. However, the more pictures you take and the better they get, the more you will want to keep. Those numbers are going to increase quickly, and once you begin to store several thousand images, you will need a more efficient way of locating them.

The answer is to catalogue them. I catalogue my files using a software application called Extensis Portfolio. This involves giving each image a sequential reference number before 'dragging and dropping' them into a Portfolio catalogue that I have created. I add a description of the subject and append keywords to help with retrieval later on. The great beauty of this software is that it is location independent – once Portfolio knows where the original file is kept, it will always be able to find it. Once the images are catalogued, you can simply search on the reference number (if known), a keyword or a description to locate the relevant images.

You can also attach a more detailed description to your images for future reference.

▶▶▶

Appendix 1: Camera care

The cameras and equipment used for wildlife photography are often exposed to extremes that can easily ruin them. A little thought and care can ensure that your gear withstands the rigours of the great outdoors and lasts for many years to come.

In the field

- ❏ When outside, try to minimize the amount of time your camera is exposed to moisture. If it does get wet, dry it off quickly with a soft cloth.
- ❏ If using the camera near or on water, you might consider using a dry bag (sold by adventure stores) when storing it, to protect it in case it falls into the water.
- ❏ If photographing near to the sea or rushing water, use a UV filter to protect the front lens element.

- ❏ In dusty environments, change lenses in a clean plastic bag to avoid dust entering the camera chamber and sticking to the low-pass (or anti-alias) filter in front of the photo-sensor.
- ❏ Always ensure that the camera is secure when travelling to avoid dropping it.
- ❏ To clean the front lens element, use a blower brush to remove large particles of dust and dirt and, if necessary, use a specially designed micro-fibre cloth to clean the lens surface.
- ❏ Wipe the LCD screen with a dry, soft cloth to remove dirt and dust.

Equipment

Lens cleaners

Use a blower brush or compressed air on a regular basis to clear dust and dirt from the camera body and lens barrel.

General care

- ❏ Never touch the low-pass (or anti-alias) filter or the photo-sensor with your fingers or any non-specific tool.
- ❏ Never clean the front lens element with an article of clothing, handkerchief or other non-specific cloth, and avoid touching the glass with your fingers.
- ❏ Store batteries away from the camera during periods of prolonged non-use.
- ❏ Always store the camera with a body cap covering the lens mount or with a lens attached to the camera.
- ❏ Always replace the lens cap and rear lens cap when storing lenses.
- ❏ Store cameras and lenses out of direct sunlight and in a cool, dry environment.

Cleaning the photo-sensor

It is sensible to have the photo-sensor cleaned by an authorized repair centre. However, if you decide to clean the sensor yourself, use only materials designed specifically for the task.

I clean my own sensor using a specialist solution and swab kit. First, having removed the lens, I lock the mirror in the up position via the appropriate menu option. I then use a manual blower to remove any significant particles of dust. After applying the solution to the swab I swipe it across the low-pass filter twice, once in each direction (left to right and then right to left). I then return the mirror to the down position and replace the lens.

Photo-sensors are delicate items and must be cleaned with care. If you feel unsure about doing the job yourself, take your camera to an authorized service centre.

In wet weather, a polythene bag or similar item secured to the camera will help to protect delicate and vulnerable equipment from water penetration.

Appendix 2: Glossary

Aliasing Refers to the stepped or jagged appearance of diagonal lines, edges of circles, and so on, in images (especially when magnified). This is due to the square nature of pixels. 'Anti-aliasing' averages out the pixels around the edge to make them appear smoother.

Artefacts General term for unwanted effects in a digital image. These include aliasing, moiré and noise.

Buffer Memory in the camera that stores digital photos before they are written to the memory card.

Burning Selectively darkening part of a photo with an image-editing program.

Burst Rate The number of consecutive frames that can be taken before 'lockout' occurs. A standard 35mm film camera has a burst depth of 24 or 36 frames – i.e. the length of a roll of film. At a continuous rate of 3 frames per second (fps), a camera will shoot 36 frames in 12 seconds. In digital photography, the burst rate is also determined by factors such as the size of the buffer and the size of the image files.

CCD Charge-Coupled Device. One of the two main types of image sensor used in digital cameras. When a picture is taken, the CCD is struck by light coming through the camera's lens, in the same way that it would strike film. See also CMOS.

CD-R CD-Rom. A compact disc that holds up to 700mb of digital information. Creating one is commonly referred to as burning a CD. A CD-R can only be written to once, and is a good storage medium or back-up device for digital photos. Rewritable versions (referred to as CD-RW) are also available.

CMOS Complementary Metal-Oxide Semiconductor. One of the two main types of image sensor used in digital cameras. Its basic function is the same as that of a CCD.

CMYK Cyan, Magenta, Yellow, Black. The four colours in the ink sets of many photo-quality printers. Some printers use six ink colours to achieve smoother, more photographic prints.

CompactFlash A common type of digital-camera memory card, about the size of a matchbook. There are two types of CF card: Type I and Type II. They vary only in their thickness, with Type I being slightly thinner than Type II.

Dodging Selectively lightening part of a photo with an image-editing program.

Download The process of moving computer data from one location to another. Though the term is normally used to describe the transfer, or downloading, of data from the internet, it is also used to describe the transfer of photos from a memory card to the computer.

FireWire A type of cabling technology for transferring data to and from digital devices. Some professional digital cameras and memory-card readers connect to the computer over FireWire. FireWire card readers are typically faster than those that connect via USB. Also known as IEEE 1394, FireWire was invented by Apple but is now commonly used with Windows-based PCs as well.

Histogram A graphic representation of the range of tones from dark to light in a photo. Some digital cameras include a histogram feature that enables a precise check on the exposure of the photo.

Image Browser An application that enables you to view digital photos. Some browsers also allow you to rename files, convert photos from one file format to another, add text descriptions, and so on.

IBM Microdrive An alternative form of digital-image storage media to a CompactFlash card. A Microdrive is literally a miniature hard drive, unlike a CF card, which uses solid-state technology.

Image Editor A computer program that enables you to adjust an image to improve its appearance. With image-editing software, you can darken or lighten a photo, rotate it, adjust its contrast, crop out extraneous detail, remove red-eye, and so on.

Image Resolution The number of pixels in a digital photo is commonly referred to as its image resolution.

JPEG A standard for compressing image data developed by the Joint Photographic Experts Group, hence the name JPEG. Strictly speaking, JPEG is not a file format, it is a compression method that is used within a file format, such as the JPEG format common to digital cameras. It is referred to as a 'lossy' format, which means some quality is lost in achieving JPEG's high compression rates. Usually, if a high-quality, low-compression JPEG setting is chosen on a digital camera, the loss of quality is not detectable to the eye.

LCD Liquid Crystal Display. A low-power monitor often used on the top and/or rear of a digital camera to display settings or the photo itself.

Moiré A wavy pattern that can appear in images when the subject has more detail than the resolution of the camera. (Technically, the 'spatial frequency' of the subject is higher than the resolution.)

Noise A type of unwanted interference in digital images. The causes are complex and varied, but the effects are most visible in uniform surfaces, appearing as monochromatic grain similar to film grain and/or as coloured waves. Noise often increases at higher ISO ratings (this is known as 'signal amplification') and during long exposures. It tends to be less of a problem with newer cameras and can be further decreased using noise-reduction technology.

Pixel Picture Element. Digital photographs are comprised of millions of them; they are the building blocks of a digital photo.

RAW An image format that uses no in-camera processing. Shooting parameters are 'attached' to each image and can be altered later using a computer.

RGB Red, Green, Blue. The three colours to which the human visual system, digital cameras and many other devices are sensitive.

Serial A method for connecting an external device such as a printer, scanner, or camera, to a computer. It has been all but replaced by USB and FireWire in modern computers.

Thumbnail A small version of a photo. Image browsers commonly display thumbnails of several photos, or even dozens at a time.

USB Universal Serial Bus. A protocol for transferring data to and from digital devices. Many digital cameras and memory-card readers connect to the USB port on a computer. USB card readers are typically faster than cameras or readers that connect to the serial port, but slower than those that connect via FireWire. USB 2 is faster than the older version (which is referred to as USB 1 or just plain USB).

White Balance A function on a digital camera to compensate for the different colours (or 'temperatures') of light that are emitted by different light sources.

Appendix 3: Camera terms

For purposes of simplicity, it has been necessary to use generic words or phrases for some of the technical terms used in this book. In reality, however, the situation is much more complex. Technical names/terms differ not only between manufacturers, but also between specific camera models. The table below highlights these terms and indicates some variations. No such table could claim to be definitive – not least because some names/terms have no exact equivalent – but it should at least provide a useful starting point.

Generic most or frequently used term	Nikon	Canon	Pentax	Sony	Olympus	Fujifilm	Kodak	Sigma
Continuous servo autofocus		AI servo	AF-Continuous					AF-Continuous
Anti-vibration technology	Vibration Reduction	Image Stabilization		Anti-shake System				Optical Stabilization
RAW file	NEF					CCD-RAW		
Camera menus (Generally: Set-up, Shooting, Playback and Custom)			Most functions built into main menu	Record, Play and Set-up	Record, Play and Set-up		Basic, Capture, Review, Image Tools and Custom	Most functions built into main menu
White balance								
• Incandescent		Tungsten	Tungsten	Tungsten				
• Daylight	Sunlight				Sunny		Sunny	Sunlight
• Cloudy								Overcast
• Custom	Preset		Manual		Manual		Click Balance	
Exposure modes								
• Shutter priority (S)		(Tv)						
• Aperture priority (A)		(Av)						
• Sport			Action					
• Close-up			Macro		Macro			
Metering modes								
• Multi-segment	Matrix	Evaluative		Honeycomb	Digital ESP	3D Matrix		Evaluative
• Spot							Centre Average	Centre
• Centre-weighted								

About the Author

Chris Weston is a full-time wildlife photographer and photojournalist who strives to highlight current environmental issues surrounding animals and their habitats. His work has taken him to many environments – from quiet urban settings to some of the most hostile regions of the world – but whatever the location he has a proven ability to capture the right image time after time.

As well as running various photography workshops, Chris operates a successful image library and a photographic tour company. He is also a regular contributor to numerous photography magazines, and is the author of several books, including *The PIP Expanded Guide to the Nikon F5*, *The Photographic Guide to Exposure* and *Start Taking Great Landscape Photographs*, all published by the Photographers' Institute Press.

Index

Photographers' Institute Press,
Castle Place, 166 High Street, Lewes,
East Sussex BN7 1XU, United Kingdom

Tel: 01273 488005 Fax: 01273 402866
Website: www.gmcbooks.com

Contact us for a complete catalogue, or visit our website.
Orders by credit card are accepted.